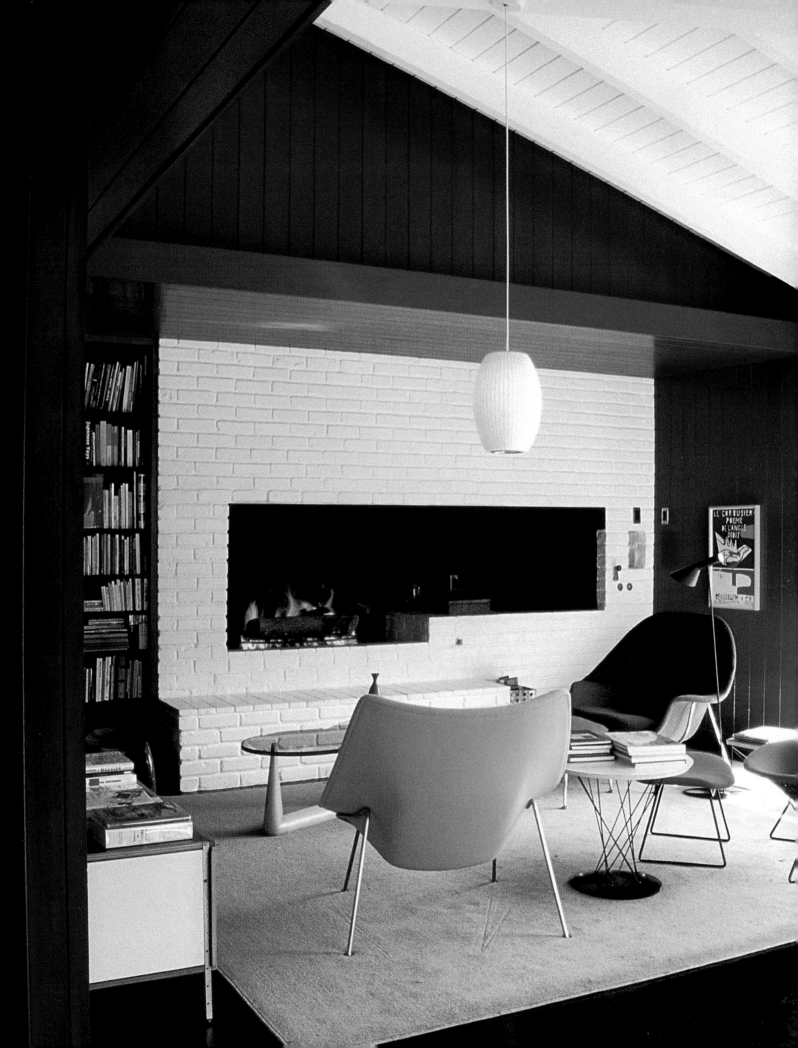

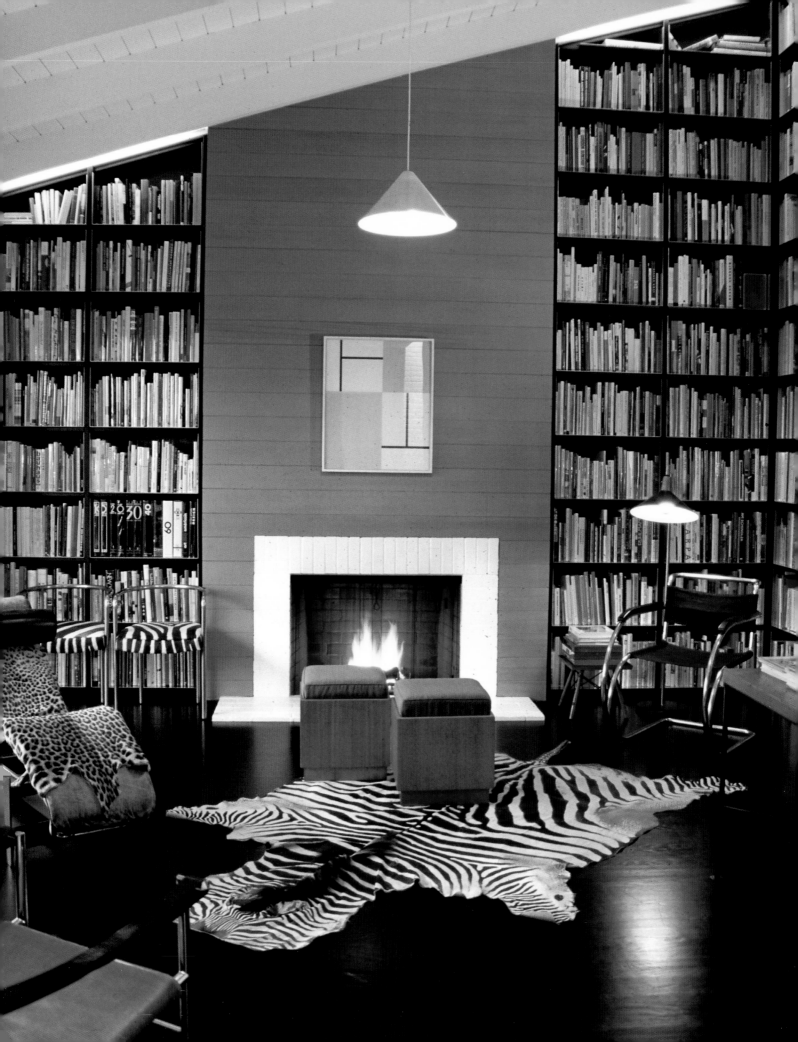

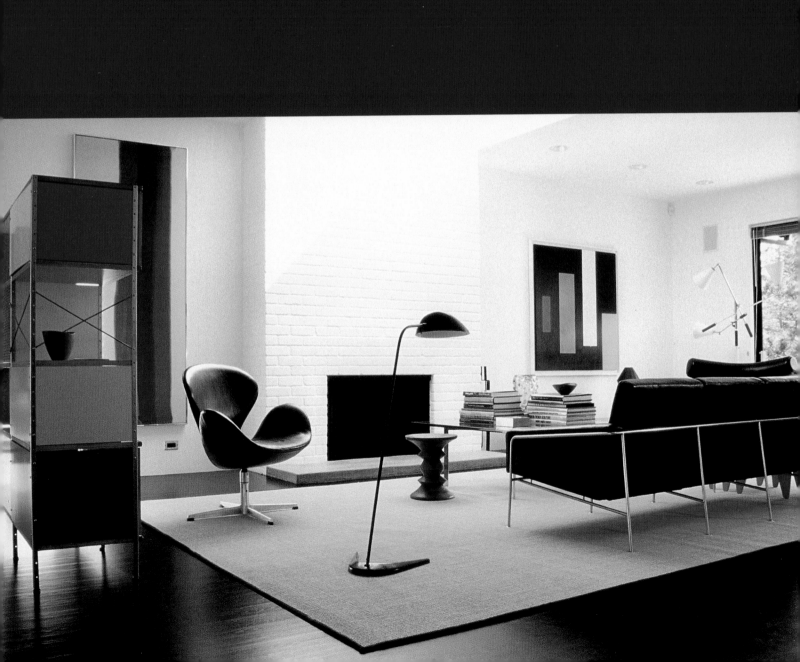

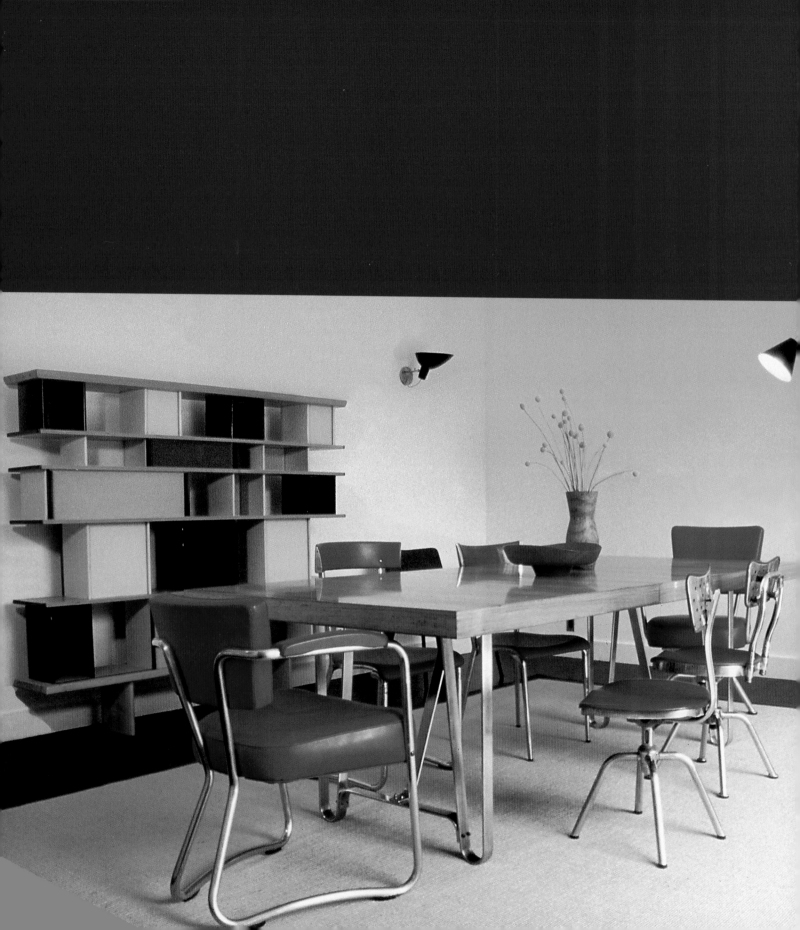

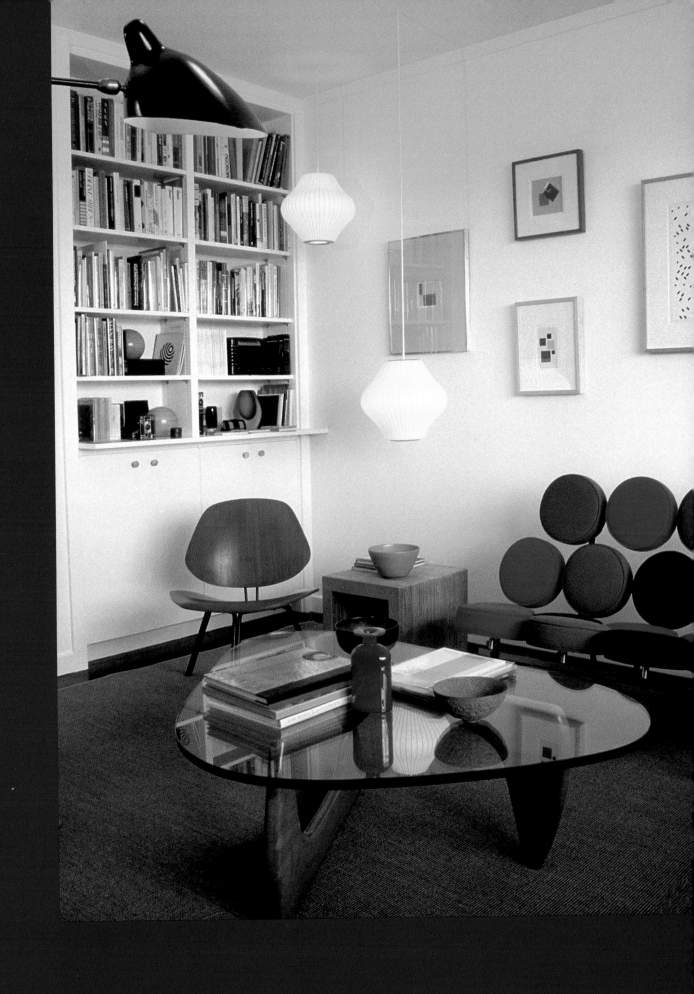

SITTING ON THE EDGE

MODERNIST DESIGN
FROM THE COLLECTION OF
MICHAEL & GABRIELLE BOYD

WITH
ESSAYS
BY
PAOLA ANTONELLI
AARON BETSKY
MICHAEL BOYD
&
PHILIPPE GARNER

SAN FRANCISCO MUSEUM OF MODERN ART
RIZZOLI

THIS CATALOGUE IS PUBLISHED ON THE OCCASION
OF THE EXHIBITION

SITTING ON THE EDGE:
MODERNIST DESIGN
FROM THE COLLECTION OF MICHAEL
AND GABRIELLE BOYD

ORGANIZED BY
AARON BETSKY
AT THE
SAN FRANCISCO MUSEUM OF MODERN ART
AND ON VIEW FROM
NOVEMBER 20, 1998, TO FEBRUARY 23, 1999

PUBLICATION MANAGER:
KARA KIRK

EDITOR:
KAREN JACOBSON

DESIGNERS:
LORRAINE WILD
&
AMANDA WASHBURN

PUBLICATION ASSISTANT:
ALEXANDRA CHAPPELL

PRINTED
& BOUND IN
GERMANY AT CANTZ

© 1998

Hardcover copublished by
Rizzoli International
Publications, Inc.
300 Park Avenue South
New York, NY 10010
Distributed by St. Martins Press

COVER:
GERRIT RIETVELD
STELTMAN CHAIR, 1964
cat. no. 120

BACK COVER:
GEORGE NELSON ASSOCIATES
MARSHMALLOW SOFA, 1956
cat. no. 86

FRONTISPIECE:
GEORGE NELSON ASSOCIATES
DAF CHAIR FROM THE
SWAGGED-LEG SERIES, 1956–58
cat. no. 87

PAGES 1–7:
Photographs of the Boyd home
by Thom Faulders

LIBRARY OF CONGRESS CATALOGING-IN-PUBLICATION DATA:

Sitting on the edge : modernist design from the collection
of Michael and Gabrielle Boyd / Aaron Betsky . . . [et al.].
 p. cm.
 Published on the occasion of an exhibition at the San Francisco
Museum of Modern Art, Nov. 20, 1998–Feb. 23, 1999.
 ISBN 0-8478-2167-6 (hard). — ISBN 0-918471-49-4 (soft)
 1. Chairs-History-20th century-Exhibitions.
2. Furniture—History—20th century—Exhibitions. 3. Boyd, Michael—
Art collections—Exhibitions. 4. Boyd, Gabrielle—Art
collections—Exhibitions. 5. Chairs—Private collections—
United States—Exhibitions. 6. Furniture—Private collections —
United States—Exhibitions. I. Betsky, Aaron. II. San Francisco
Museum of Modern Art.
NK2715.S56 1998
749.2'049'07479461-dc21 98-40463
 CIP

FOREWORD

Michael and Gabrielle Boyd share a number of the well-known attributes of collectors of art and design. For them, collecting has become an obsession—for Michael, in fact, it began with baseball cards, moved on to electric guitars, and culminated in design objects and furniture, which he began amassing in his early twenties. Like many collectors, the Boyds have focused on a defining area of interest that—despite the geographic and historical breadth of their collection—unites hundreds of works under the overarching aesthetic ideal of clear, unadorned modernist design. And, like some truly committed collectors, the Boyds have combined their collecting with an avid quest for information and knowledge, establishing a library of books on modernist design that is as comprehensive as their collection of objects.

A visit to the Boyds' home, however, immediately sets them apart from the typical collector of paintings, sculpture, or photographs. The visitor sits on their collection, eats dinner off their collection, tells the time using their collection. Indeed, the Boyds live in, on, and amid their collection, and it has not only defined their aesthetic sensibilities but has also become an integral, fundamental, all-encompassing part of their lives. Perhaps this deep union with the work derives from Michael's own creative expression, which began from a point of reduction—a paring down to the essential elements—which is also the point of origin for the collection.

As personal as any collection is—and certainly the Boyd collection is a reflection of Michael and Gabrielle—this collection has been informed by the more ambitious goal of creating a complete survey of twentieth-century modernist furniture design. The collection begins with work from early in the century and ends abruptly in the 1960s, when modernist design was displaced by postmodernism as the prevailing standard for the elite and the everyday alike. In the Boyd collection the great figures of modern design—Marcel Breuer, Charles and Ray Eames, Ludwig Mies van der Rohe, George Nelson, Gerrit Rietveld, and Frank Lloyd Wright—are represented by the most essential manifestations of their work, which embody the central tenets of modern design, from formalist invention to theoretical ideal.

Most happily for the San Francisco Museum of Modern Art, the Boyds have chosen to align themselves with our Department of Architecture and Design, making gifts of some sixty design objects over the past couple of years. Their aspiration is to work with the Museum to create a public repository for what they have already established: a great home for twentieth-century modern design. We are most grateful, first and foremost, to Michael and Gabrielle Boyd for their generosity in forming this legacy and, most immediately, for allowing us to empty a good portion of their home for this exhibition of some 150 works.

The exhibition and the catalogue that accompanies it are the result of a wonderful partnership between the Boyds and the San Francisco Museum of Modern Art's curator of architecture and design, Aaron Betsky, and we thank Aaron for bringing his own lively perspective and deep understanding of the work to this project. Aaron was ably assisted in the organization of the exhibition by Thom Sempere, manager of graphic study; Melanie Ventilla, curatorial assistant; Susan E. Bartlett, acting assistant registrar; and Amos Klausner, assistant in the Department of Architecture and Design at SFMOMA.

The catalogue is the result of the extraordinary efforts of a number of people, including Michael Boyd, who wrote two insightful essays for the book. Joining him in making important contributions to this publication are Paola Antonelli, associate curator in the Department of Architecture and Design at the Museum of Modern Art, New York; Philippe Garner, a senior director of Sotheby's, London; and Melanie Ventilla, who prepared the catalogue of the exhibition (which begins on page 153 of this volume) and wrote texts on several key works in the collection. The extensive new photography for this book was undertaken by Ian Reeves, who was responsible for the images of the individual objects, and Thom Faulders, who photographed the works in situ in the Boyds' home. We extend our deep appreciation to Karen Jacobson, the book's excellent editor, and Lorraine Wild and Amanda Washburn, whose design so keenly captures the collection's sensibility. We thank our colleagues David Morton, Solveig Williams, and Katherine Adzima at Rizzoli, the copublisher of the book. We are also grateful to Sarah Emmer, who assisted with securing copyright permissions, and to Kate Hofstetter, assistant to Michael Boyd. Finally, special thanks are due to Kara Kirk, publications and graphic design director, and Alexandra Chappell, publications coordinator, for managing the many complex aspects of this catalogue.

On behalf of Gabrielle and Michael Boyd, we would like to thank Simon Andrews, Michael Boloyan, Bill Clarke, John Conaty, Catherine and Stephane De Beyrie, Michael Engle, Ken Erwin, Thom Faulders, Greg Favors, Adrienne Fish, Linda Gershon, Marc Haddawy, Chris Houston, Mark Isaacson, Daren Joy, Daven Joy, Fred Lech, Eric Lamers, Marc McDonald, David Shaw, William Stout, Timothy Street-Porter, Suzy Vandeneynde, and Pilar Vilades.

SFMOMA's architecture and design collections—as well as its exhibitions, publications, lectures, and other programs relating to these disciplines—are dedicated not only to advancing our shared awareness of the built environment but also, just as importantly, to enhancing our understanding of the ideas and intellectual paradigms that have emerged from a century of modernism. The Boyd collection argues for a standard of design where livability and aesthetic achievement are in harmony—where "on the edge" is just where you want to be sitting.

David A. Ross
Director
San Francisco Museum
of Modern Art

MODERNISM: THE ART OF REDUCTION

AN INTERESTING PLAINNESS IS THE MOST DIFFICULT
AND MOST PRECIOUS THING TO ACHIEVE
R. M. SCHINDLER [1]

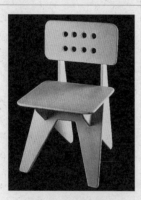

If I were to trace a thread through our collection, it would have to be that each object is a minimal expression of some sort. From the turn-of-the-century Otto Wagner (c. 1902; pl. 2) and Peter Behrens (1903; pl. 1) side chairs through the Folke Arström cocktail shaker (1936; cat. no. 4) and the Carlo Scarpa vase for Venini (1936; cat. no. 125) to the Verner Panton vacuum-plastic stacking chair (1960; pl. 95) and the Burgoyne Diller First Theme paintings (1959–64; cat. nos. 28–30, pl. 102), all the pieces in *Sitting on the Edge* are reductive. *Minimal*, as I mean it here, does not refer specifically to the 1960s minimalist art of Dan Flavin, Donald Judd, Robert Morris, and others, but describes the general paring down in art and design to only meaningful elements—the minimum needed to capture and sustain interest.

In his recent book *Minimum*, the contemporary London-based architect John Pawson takes a highly subjective look at a more inclusive definition, one that includes fourteenth-century Chinese scrolls, grain silos, African Dan masks, Japanese raked sand gardens, agricultural topography, Hiroshi Sugimoto's photographs, Georgian silver, and Luis Barragan's architecture—things from all places and times which share a silence and purity.[2] I think all of the objects in *Sitting on the Edge* can be seen in this looser context; the idea is to make something simple, not simplistic. Clarity and content are the common threads.

I come to this question as a maker of art and design. I have spent much time creating reductive paintings, minimal furniture design, and architectural design and re-design. As trite as it may sound, it is incredibly difficult and painstaking to create a competent piece of reductive work. Like many young art students (I went to the University of California, Berkeley, in the late 1970s and early 1980s), I copied Mondrian's and Malevich's compositions, and I was immediately struck by the deceptive chore of hunting down that elusive perfection of scale and quality of surface. And, early on, I dabbled in furniture design, with the same result. Although

I was attracted to the notion of creating a functional object with no superfluous ornamentation, a misplaced millimeter here or there was the difference between a calm, well-balanced, self-contained object and an awkward piece of rubbish.

There was another variable in the equation, which came up soon after I completed even a modest body of acceptable work. I would slave over a reductive painting into the wee hours, only to go to studio class in the morning and have professors and students alike say "Interesting . . . Ellsworth Kelly, 1956" or "Yes . . . Barnett Newman, 1949" or "Yeah, I love Frank Stella's metallic paintings too." It became clear that (1) if I wanted to create anything of originality, I needed to know the history of my predecessors, so that I wouldn't repeat things in an uninformed way, and (2) that contemporary artwork often had a dialogue going with earlier works and artists (e.g., Burgoyne Diller using a black background to distinguish his neoplastic works

Figure 1
Michael Boyd and Eric Lamers
Chair, 1989 (cat. no. 14)
Douglas fir plywood, gesso

Figure 2
Michael Boyd and Daven Joy
Telephone table, 1991 (cat. no. 13)
Maple, aluminum paint

Figure 3
Michael Boyd
Untitled Construction, 1991 (cat. no. 12)
Oil on wood

from Mondrian's, or even Holt, Hinshaw, Pfau, and Jones plagiarizing a work with a small, footnotelike addition, as in their version of a Corbusier chaise on hydraulic lifts). Researching the historical background of works that I was drawn to became a major preoccupation and, indeed, a true love. I would discover almost identical precedents for Tony Smith paintings in the works of Sophie Taeuber-Arp and Walter Dexel thirty years earlier. I would find early ancestors of my favorite modernist furniture designs in eighteenth-century Shaker work and antecedents of functionalist modern architecture in four-hundred-year-old Japanese temples.

So all of these issues would come together in the collection: the minimal impulse as a painter and object builder, the reverence I felt for the artists who created first-rate works in this area, and my interest in the historical context that linked these artists. Combine these with the fact that I was a born salvage maniac

and inveterate flea-marketer (I would look at Rauschenbergs in museums and think to myself, "I know where he got that tire and that shirt and that rope . . ."), and you can see how this whole thing got started.

Somewhere along the way there came a turning point. Like an overly conscientious couple discussing the moral dilemma of whether or not they should bring yet another child into this troubled world, I found that my own impulse to create more physical objects waned and my output diminished. My creative longings were transferred to an impulse to sort through and reorganize things that already existed—collecting the works of others—and this was truly satisfying. And I felt smothered by a derivative element in my paintings and furniture designs—the clear debt to Gerrit Rietveld and Donald Judd, for example—and this made me pull back and rethink my role. So in 1981, inspired by the exhibition *Marcel Breuer: Furniture and Interiors* at the Museum of Modern Art in

New York (MoMA), and by a deepening awareness of the Case Study House program put forth by John Entenza and *Arts and Architecture* magazine, I began to collect.[3]

But to get back to the minimal aesthetic that influenced the acquisitions, I remember, as a kid, watching *2001: A Space Odyssey* and being transfixed by the monolith. What was it about this permanent, impermeable, simple rectangular box that inspired devotion? It was not the religious or cultural iconography that captivated me. I was somehow aware of all the things it might have been but wasn't, what Pawson calls the "presence of absence." Whether interpreted as a solid mass or a receptacle whose contents are not revealed, it was reduced to the limit; it was pure and total and perfect and somehow stronger than the implied earlier incarnations.

The first "collected" piece included in *Sitting on the Edge*

shared the dense, atomic character of the mesmerizing monolith of *2001*. Again, it could not have been reduced further and seemed irrefutable. It was an Eames fiberglass chair (RAR, 1950; pl. 65), and in 1981 it was readily accessible and affordable. Then came an Arne Jacobsen Ant Chair (1952; fig. 26), followed by a streamlined Kem Weber piece, since upgraded to his Airline Chair (1934–35; pl. 39), and suddenly I was swept away.

Only now, in reviewing all the pieces included in the exhibition, have I been able to retrace what was taking place: the concentrated strength and purity of certain pieces, an indefinable "correctness" and "completeness," was overpowering and alluring. In an unknowing but obsessive way, first I and then, following our marriage in 1989, Gabrielle and I would seek out works (paintings, chairs, bowls, staplers, hat racks, etc.) with this minimal sensibility in common. In fact, Gabrielle had the excellent sense to notice early on that that it was woefully ironic that we were amassing "tons of minimalism."

Figure 4
Michael Boyd
Untitled, Four Part Painting, 1990 (cat. no. 11)
Acrylic on canvas mounted on plywood

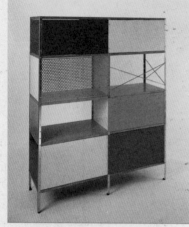

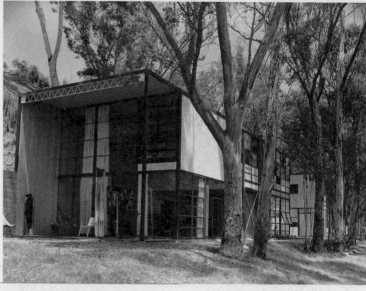

In thoroughly researching the history of twentieth-century design and its avant-garde movements, we realized that there was a mass of dogma and doctrine that we hoped to avoid. Not only artists but also museums and collections could be strangled by a too-narrow mandate; we hoped to stay open and receptive and not get hung up on historicism or well-trodden "textbook" modernism. We wanted to make new and vibrant connections and associations. Still, the model that guided us seemed clear enough: we were steeped in the visual literacy of MoMA's architecture and design department. In its fourth-floor galleries the late nineteenth-century and early twentieth-century works of Antonio Gaudí and Hector Guimard coexisted seamlessly with a mid-1960s experimental polyurethane chair by Gunnar Andersen and anonymous objects of industry like a hockey goalie's mask.

As the collection grew, a parameter made itself evident: we were compiling a survey of twentieth-century avant-garde design, mostly the work of architects, never the work of interior designers or decorators. This is not to say that there are not outstanding pieces by, say, Terrance Robsjohn-Gibbings, Edward Wormley, or other "interiors" people, but their efforts seemed conceptually weak in comparison with the architects' clear path to form, function, and abbreviation—perhaps driven more by the creature comfort marketplace (and more closely linked to nineteenth-century *ébénistes* and furniture makers and their tradition of craft).

By 1990 we knew "what" we collected, and as our commitment to avant-garde modernism deepened, we zeroed in on the "where" and the "when." It seemed important to keep the collection international. We began acquiring works by Pierre Chareau, Rene Herbst, and Robert Mallet-Stevens from France; Gio Ponti, Giuseppe Terragni, and Marco Zanuso from Italy; Vilmos Huszar, J. J. P. Oud, Gerrit Rietveld, and Mart Stam from Holland; Peter Behrens, Ludwig Mies van der Rohe, and Wilhelm Wagenfeld from Germany; Josef Hoffmann and Otto Wagner from Austria; Max Bill, Hans Coray, and Willy Guhl from Switzerland; Arne Jacobsen and Hans Wegner from Denmark, as well as the requisite Americans: Charles and Ray Eames, George Nelson, and Frank Lloyd Wright.

The timeline started with the turn of the century (we resisted interesting and seductive proto-modernist work by Christopher Dresser, Richard Riemerschmid, Louis Sullivan, and Michael Thonet, among others), when elaborate finishes and historicist ornament gave way to functionalist clarity, honesty, and overt materiality. The intuitive closing date seemed to coincide perfectly with the arrival of postmodernism, announced by the publication of Robert Venturi's *Complexity and Contradiction in Architecture* in 1966,[4] followed in the 1980s by the Memphis revolution in industrial design, which seemed to return to a kind of historicism, employing metaphor, allusion, and other literary devices.

Given my own constructivist tendencies, it would follow that the works of Breuer, Rietveld, Wright, Richard Neutra, Rudolph Schindler, and the like inspired the deepest passion. I was fascinated by the notion that a chair or piece of functional design could suggest, sometimes encapsulate, the architecture and sense of space of its creator. Historians have noted at length the inseparable connection between Rietveld's Schröder House (1924) in Utrecht and his Red/Blue Chair (1918; pl. 8) or between the Eames House in Pacific Palisades (1949; fig. 6) and Charles and Ray's storage unit for Herman Miller (1949–50; fig. 5).

Figure 5
Charles and Ray Eames
Storage unit, 1949–50 (cat. no. 34)

Figure 6
Charles and Ray Eames
Eames House, Pacific Palisades, 1949

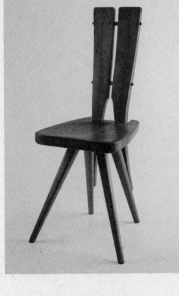

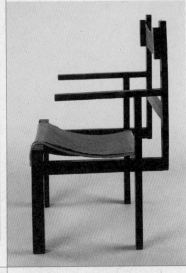

And there is another strain in design that is crucial to our collection: the organic, lyrical, or biomorphic impulse. For example, the Italians Carlo Mollino and Franco Albini (see pls. 75, 71) seem to represent a complete break with the constructivist/rationalist line of thought, but their works are in fact "constructive." These highly personal, even eccentric efforts are beautifully and simply crafted. Although they can exhibit an opposing poetic tendency, they share with the machined and planar pieces in *Sitting on the Edge* a visceral materiality and a search for "essence." While the rationalist, rectilinear examples seem to be aligned by virtue of a keen understanding of interlocking planes and their variances, these pieces—as well as the Sori Yanagi stool (pl. 80), the shell forms of Arne Jacobsen, and other works—represent the purest and most concentrated brand of poet-icism: a kind of lean and hopeful lyricism.

The contrasting planar and organic tendencies are not so distantly related. Donald Judd always asserted that he felt his work had more of an affinity with the drip paintings of Jackson Pollock than with the work of geometric abstractionists like Al Held or Leon Polk Smith. By virtue of the "alloverness" and noncom-position of their works—the fact that you can "read" the work instantly in its totality and that it sets a singular goal for itself and does not back down from the task—there is a sympathy of inten-tionality between Pollock and Judd. In a similar way, with regard to conceptual underpinnings, the anthropomorphic stereo imagery of Mollino's split-back chair for the Casa del Sole (1947; fig. 7) is not so distant from the slatted armchair Breuer created at the Bauhaus (1922–24; fig. 8), despite their disparate appearances. They are both expressions of a kind of economy and radicalism, and they are both physical manifestations of the "exploded view" (as in a working blueprint come to life). Moreover, they both embody a major tenet of modernism, one that runs throughout *Sitting on the Edge*: the art of reduction.

NOTES
1. Rudolph M. Schindler, "About Furniture," *Los Angeles Times*, 18 April 1926; reprinted in *The Furniture of R. M. Schindler*, ed. Marla C. Burns (Santa Barbara: University Art Museum, University of California), 41.
2. John Pawson, *Minimum* (London: Phaidon, 1996).
3. See Christopher Wilk, *Marcel Breuer: Furniture and Interiors*, exh. cat. (New York: Museum of Modern Art, 1981).
4. Robert Venturi, *Complexity and Contradiction in Architecture* (New York: Museum of Modern Art, 1966).

Figure 7
Carlo Mollino
Side chair for the Casa del Sole, Cervinia, Italy, 1947 (cat. no. 79)

Figure 8
Marcel Breuer
Slatted Armchair, 1922–24 (cat. no. 15)

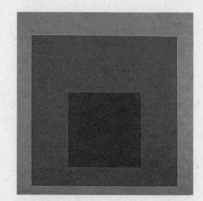

MODERN DESIGN: THE QUEST FOR IDEAL FORM

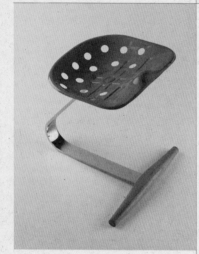

The pursuit of the "modern" seems to have become an obsessive preoccupation of the culturally aware of the twentieth century. Perhaps it was always so, with fashions in dress, decor, art, and manners providing the points of reference by which people climbing or at the top of the social ladder could mark their position and achievements. The early years of the twentieth century, however, witnessed the most dramatic breaks with tradition in art and design and ushered in a distinct new emphasis on the concept of "modern." The epithet assumed new layers of meaning, suggesting something of intellectual substance, diametrically opposed to the superficiality associated with merely fashionable or snobbish concerns. After the social and political upheavals of World War I and the Russian Revolution, it was hardly surprising that a new social and cultural climate should encourage a complete renewal of the language of art and design. Revolutionary ideas found expression in the theories and programs of avant-garde groups in the cities of Berlin, Paris, New York, Amsterdam, and Vienna and in Italy and Russia. Artists and thinkers of the Dada movement were among the most radical in their anarchic proposals for

the destruction of hierarchical bourgeois conventions and standards and a reappraisal of social and artistic values. Emerging design movements sought to give form to a vision of the modern as expressive of a new order, embracing democratic, utopian ideals.

The Michael and Gabrielle Boyd collection brings together, in a comprehensive didactic sequence, works illustrative of the birth of this ideal of the modern and of its evolution through the century. The collection is effective in demonstrating the sustained power of modernist ideals from their emergence at the beginning of the century in Germany and Austria up through the point in the 1960s when artists, designers, and critics started to call into question the once-secure theoretical underpinnings of the modern movement. The rationalist theories of modernism were challenged by talk of "anti-design" and by a postmodern sensibility that acknowledged the full potential of design as complex metaphor. These opposing approaches can be well illustrated by juxtaposing specific works in the Boyd collection. A painting by Josef Albers perfectly expresses the purist aspirations of the modern movement. In contrast, seat designs by Italians Carlo Mollino and Achille and Pier Giacomo

Castiglioni exemplify the search for a more complex and questioning symbolism, anticipating pop and postmodernist attitudes.

Albers's Homage to the Square series (see fig. 10, pl. 101) involves a curious act of worship. This German artist and art teacher, who taught as a master at the Bauhaus from 1923, created a series of works devoted to forms of pure geometric perfection which do not exist in nature. They demonstrate a faith in the human potential to make tangible an intellectual ideal of form and structure. Albers's devotion to the straight line and the angle and his implicit recognition of their symbolic value has its design counterpart in Gerrit Rietveld's interplay of lines and planes, the Red/Blue Chair of 1918 (pl. 8). From within the Boyd collection one might easily draw a family tree tracing the lineage of this homage to strict rectilinear construction. It would embrace Marcel Breuer's slatted armchair of 1922–24 (pl. 10), Richard Neutra's minimalist table of 1948 (pl. 58), Charlotte Perriand and Jean Prouvé's wall unit of 1952 (pl. 70), and Burgoyne Diller's First Theme series of 1959–64 (pl. 102).

Figure 9
Achille and Pier Giacomo Castiglioni
Mezzadro Stool, model 220, 1957
(cat. no. 22)

Figure 10
Josef Albers
Homage to the Square, Green Tension,
1951 (cat. no. 2)

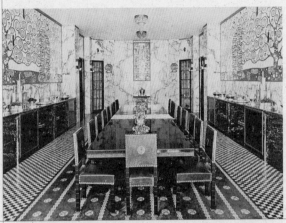

Mollino and the Castiglioni brothers, in marked contrast, demonstrate an approach to design in which rationalism is spiced with sensuality and willful playfulness. Mollino's 1947 chair (pl. 51) is sculpted as if in anticipation of the curves of the human form that it will support, the designer's fascination with the erotic never absent from his creative impulse. The Castiglioni tractor seat stool of 1957 (fig. 9) wittily uses an *objet trouvé* and delivers it in a bold pop color. The two designs imply a wry challenge to the purists, who, with an almost religious passion, had given such potential to the chair as icon, making it the vehicle of so much theory, of so many and such ambitious ideals. These imaginative Italians were the heralds of the changes that were to come in the 1960s, the decade of pop, of the space race, of student unrest and escapist fantasy, the decade in which a new generation was to greatly extend the language of design. And fundamental to this questioning phase was the challenge made to the purist visions of modernism.

Furniture and domestic or office appliances could be the basis of a technical and practical analysis. It is to the credit of the Boyd collection that it provokes a different kind of study and a more invigorating analysis. It is a collection about the progress of ideas, and every piece in the collection is able to demonstrate that, while the first function of design is to create objects that effectively serve their purpose, designers work within a discipline in which they are also able to express ideas and to explore aesthetic concerns. A well-designed object is there to be used, but it can also have a voice. It is the mouthpiece of its creator. And if the pioneers of the modern movement and their disciples had one ambition, it was to create objects that carried a strong message in every line and detail.

These messages are quite different from those to be found in a parallel story of twentieth-century furniture and design. It should not be forgotten that the avant-garde continuum represented by the evolution of the modern movement was only one facet of the story of design and very often a minority taste at that. The old hierarchies and traditions were challenged, but they were not destroyed. Modernist designers attracted critical and press attention but had little immediate impact in the wider marketplace. The desire for display, decoration, and opulence, for furniture and artifacts whose rich materials and quality of execution made them symbols of status, continued to be well served by succeeding generations of designers, decorators, stylists, craftsmen, and artisans. They catered to the rich, to old and new money, to an affluent bourgeoisie, and to those who valued a centuries-old but still evolving language of style. Within this tradition fit the gilt-bronze orchids or lilies that ornament the sculptured mahogany of an art nouveau desk by Louis Majorelle (fig. 11), or the fine crisscrossing lines of inlaid ivory that accent the rich, dark macassar ebony of a 1920s art deco desk by Emile-Jacques Ruhlmann. Even pioneer modern movement designers such as the Austrians Josef Hoffmann and Koloman Moser were capable of being diverted from the laudably democratic task of creating elegant, clean-lined designs suitable for mass production to work with richer woods and metal and mother-of-pearl inlays at the behest of a moneyed patron (see fig. 12).

It is not, however, with the sophisticated stylists of art nouveau or art deco, the decorative interpreters of 1930s surrealism, or the devisers of 1940s neo-baroque schemes, 1950s kitsch suburban dreams, or 1960s pop fantasies that the Boyd collection is concerned. This compendium tells its own discrete tale. It is one whose crucial roots are in the emergence in pre–World War I Germany and Austria of an infra-structure that permitted and promoted high-quality industrial design.

Thonet, the firm of bentwood furniture manufacturers founded in Austria in the mid-nineteenth century, devised a new technology and created designs appropriate to that technology. In so doing, the firm was to provide a significant model for early twentieth-century designers and manufacturers with ambitions to bring good, simple design to a broad market. Going against conventions of bourgeois ostentation, Thonet developed the potential to manufacture simple, elegant seat and other bentwood

Figure 11
Louis Majorelle
Desk "aux nénuphars," c. 1900–1905
Courtesy of Sotheby's

Figure 12
Dining room in the Palais Stoclet, Brussels, executed by the Wiener Werkstätte, under the direction of Josef Hoffmann, 1905–11

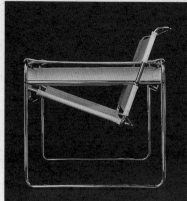

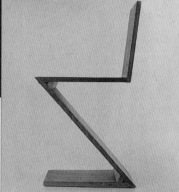

furniture in vast quantities. It was a truly democratic concept. The factory established a fine precedent for intelligent, functionalist design adapted to low-cost series production. When Hoffmann, Moser, Otto Wagner, and their associates emerged around the turn of the century as the torchbearers for new, secessionist ideas that were to have an impact in Vienna and beyond, it was inevitable that they should forge alliances with Thonet and the rival firm Jakob & Josef Kohn. While so many of their contemporaries were indulging in the decorative extremes of art nouveau, in 1900 Vienna this avant-garde group set a standard for the new century, an exemplary marriage of design and industry.

After its triumph at the Paris international exposition of 1900, which celebrated France's dominant position in every aspect of the decorative arts that involved sophisticated and opulent styling and exquisite craftsmanship, French design lost its way in the first decade of the century. While most French decorators looked to the eighteenth century for inspiration, a few, more internationally aware, looked beyond France for new directions and noted with envy the extent to which Austria and Germany were

taking the lead in finding new and entirely forward-looking approaches to design. The Wiener Werkstätte, founded in 1903, and the Deutscher Werkbund, set up in 1907, were conceived with the objective of bringing together educators, designers, and makers in a harmonious and productive alliance.

The career of designer and teacher Peter Behrens well demonstrates the shift in values that gave so great an international importance to German design theory in the early years of the century. First achieving renown within the context of the Darmstadt artists' colony around 1900, Behrens was appointed director of the Kunstgewerbeschule in Düsseldorf in 1902. Named "artistic adviser" to AEG (Allgemeine Elektrizitäts-Gesellschaft) in 1907, he became the design force behind this major manufacturer of domestic electrical and other appliances.

From elitist decoration to teaching to the implementation of a practical idealism, Behrens's progress reflected the democratization of the arts and their alliance with industry. These objectives, with more than a dash of expressionist fervor, were to underpin the program of the Bauhaus, the German school of art and design which was to have so profound an influence on the century. The Bauhaus was founded in

1919 at Weimar under the initial direction of architect Walter Gropius. He wrote in his manifesto of combining "everything— architecture and sculpture and painting—in a single form that will one day rise toward the heavens from the hands of a million workers as the crystalline symbol of a new and continuing faith." Gropius conjured forth enticing metaphors for the crusade that the school was undertaking. The utopian idealism that shaped its initial program involved a radical demolition of all barriers in art and design. Architecture became the central discipline around which all others flowed, with no hierarchies between painting, dance, sculpture, photography, typography, or industrial design.

This was the open context from which emerged some of the most revolutionary rethinking of design issues within the entire twentieth century. The furniture designs of Breuer and Ludwig Mies van der Rohe and the product designs of Wilhelm Wagenfeld are among the most significant to emanate from the Bauhaus. Breuer used an innovative material, tubular steel, in chairs of startling invention, easily adapted to

Figure 13
Marcel Breuer
Wassily Chair, Model B3, 1925–27
Collection of Michael and Gabrielle Boyd

mass production, the 1920s echo of Thonet bentwood. His idea of combining tubular steel bases with glass tops for tables involved the application to domestic design of two materials with which modern movement architects were simultaneously redefining architecture. Breuer's Wassily Chair, tubular steel and canvas in a taut arrangement of intersecting lines and planes, was designed in 1925, the year in which Paris hosted the *Exposition internationale des arts décoratifs et industriels modernes* (fig. 13). What a telling contrast is marked between Breuer's vision and the traditionalist mood of French art deco, all gilt-wood swags, rich damasks and veneers, wrought-iron flora and fauna, and labor-intensive lacquers.

While traditionalist designers and craftsmen were enjoying the triumph of art deco, the Bauhaus was not alone in staging a design revolution. Rietveld emerged in the Netherlands as the most inspired and inspiring architect-designer of the De Stijl group. His furniture designs were three-dimensional, one might say sculptural, equivalents of the graphic works of his De Stijl artist colleagues (see

Figure 14
Gerrit Rietveld
Zig-Zag Chair, c. 1932–34
Collection of Michael and Gabrielle Boyd

fig. 14). Practical and functional issues were to a great extent overshadowed by Rietveld's polemical ambitions in a series of designs whose force has in no way faded with the passage of time.

In France a group of designers had started to make their mark in the 1920s with a paring down of design to its structural essence, though still within the framework of the characteristically French respect for luxury craft values and chic styling. Talents as diverse as Pierre Chareau, René Herbst, Robert Mallet-Stevens, Jean Prouvé, and the Swiss-born Le Corbusier, more often than not trained as architects, shaped the French modern movement. They came together in 1930 as the Union des artistes modernes (UAM). The UAM was to have a significant impact on industrial design in France, before and after World War II, notably through its Formes utiles program. The chaise longue developed by Le Corbusier in 1928 in collaboration with Charlotte Perriand (pl. 24) has been rightly hailed as one of the landmark designs of the modern movement. In one specific respect, the quite separate treatment of supporting base and seat unit, it anticipates the work of American Charles Eames, arguably the most influential modernist designer of the 1940s and 1950s.

Eames was an architect and designer driven by a rationalist curiosity. He was ready to experiment with new materials and production techniques, and his style was one of elegant and unpretentious functionalism. Among his most important contributions to the language of furniture were his steel pedestal bases for chairs or tables, his plywood and fiberglass seat units molded in multidirectional curves, and his development of the concept of modular construction. Through a long and close relationship with the firm of Herman Miller, Eames and a group of like-minded designers, notably George Nelson, evolved a product line that has enjoyed consistent international success. Eames, more than anyone, gave an intellectual credibility to postwar American design. He had no interest in fashion, and his ideas in so many aspects of design retain a freshness and a relevance that are unsurpassed. His furniture, much of which is still in production, is as modern as when he first conceived it.

Scandinavian schools, guilds, and small-scale industries were, meanwhile, quietly laying the

Figure 15
Carlo Mollino
Untitled photocollage, c. 1950
Collection of Michael and Gabrielle Boyd

foundations of a craft, design, and industry program pitched at a broad middle class, which was to place Scandinavian design— a mellow, tactile, less overtly revolutionary brand of modernism— in a position of international prominence in the 1930s and in the postwar decades. The Boyd collection includes characteristic works by Finnish pioneer Alvar Aalto and by Danes Arne Jacobsen, Finn Juhl, and Werner Panton. Jacobsen's Swan Chair of 1957–58 (pl. 89) has a leather seat conceived in sensual curves. Panton's plastic stacking chair similarly employs sweeping curves, having more in common with the pure, organic lines of art nouveau than with the rigid geometry of conventional modernism (pl. 95). Yet this cantilever design is dramatically modern in concept, the first plastic single-unit injection-molded chair.

If one nation, however, were to take the principal credit for consistently revitalizing the language of modern design in the postwar decades, it would surely be Italy. The Boyd collection includes telling examples of Italian design, from works by the father figure of modern Italian design, Gio Ponti, through pieces by the spirited individualist Mollino and by representatives of the first

postwar generation— Franco Albini, Osvaldo Borsani, and Marco Zanuso—to the proto-pop tractor-seat stool by the Castiglioni brothers (fig. 9). The furniture and associated manufacturing industries of northern Italy enjoyed a veritable renaissance in the years of postwar reconstruction. The close-knit geography of these industries and their generally small scale created an ideal situation in which experimentation and dialogue between designers and manufacturers could flourish. Italian designers tended to reject distinctions between the disciplines of design and decoration, bringing a native flair and flourish to all aspects of product development. The Milan Triennale exhibitions became a showcase for the best international design and set a high local standard, as did the pages of *Domus*, the design magazine that became the prime visual reference of the avant-garde. From Ponti to Castiglioni, Italian modernist design has consistently ranked among the most diverse and provocative, entertaining complexities and contradictions that were to herald the demise of purist ideology and introduce new questions and new challenges into the international story of furniture and product design.

AARON BETSKY

SITTING BETWEEN CRAFT & FORM | IDEAL AND REALITY: IN THE COLLECTION OF MICHAEL & GABRIELLE BOYD

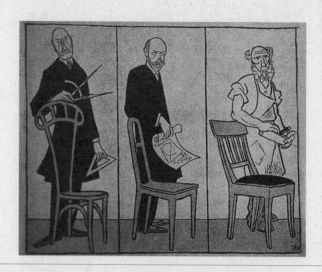

Furniture is halfway between architecture and the body. It is as abstract and addicted to big ideas as the monuments of modernist architecture but responds directly to the needs of our backs, our behinds, and our bodies. In a theoretical sense, chairs, cupboards, and cutlery express in miniature the desire many modern architects have felt to pull apart the basic forms of our surroundings, to make objects that look as if they defy gravity and a logic of measurement based on the human body. Among the best designs of this century are those that reduce all of reality to its most basic shapes. Modern furniture has us sitting on the edge of reality, almost inhabiting a new world that architects, painters, philosophers, and politicians continue to promise us.

Modern furniture was not in and of itself new. The chairs that pushed us beyond what we already knew were the products of centuries of tradition in craft, in which furniture makers worked with the materials at their disposal, teasing out of them conventional-izations of the forms one would find in nature. They made shapes that reflected the curve of the body, the mechanics of how we lift or place, and the logic of

the distribution of weight in an object. They also recalled the sense that furniture is an adaptation of limbs of a tree, twigs woven together, or stones we sit on.[1] They expressed these facts but applied them to new materials. They tried to make things that were better than what had come before as well as revolutionary in their application of new solutions to old problems and new situations. Combining the ideals of building a better world with a desire to trace the organic reality we too often replace with our man-made edifices, the great modern furniture of this century has the ability to make the new real and the real new.[2]

It is these tensions that give the collection of Michael and Gabrielle Boyd the quality of edginess embodied in the title of this exhibition. The Boyds have assembled several hundred objects that push the notion of what a piece of furniture might be all the way to the edge. These are pieces that make material do what one thinks it cannot, cantilevering beyond stability into gestural space. These are pieces that delight in the use of the new materials that make even stranger and more elegant forms possible. These are pieces that show the hands of craftspeople carving into these materials to find

their essence and constructing elaborate expressions of how they are best assembled. These are pieces whose design pushes us to the very edge of our seats with excitement.

As such, the collection traces a line that, for all the contradic-tions and different experiments embodied in the individual pieces of furniture, runs throughout the twentieth century. It is a path of experimentation that is also itself the dividing line between architecture and the body, between abstraction and craft, and between technology and organic form. It makes clear some of the inherent issues modern design of all sorts has had to face in this century. In them, it sought to answer the needs that were created as new kinds of activities were undertaken by larger masses of people living in an atmosphere of both frightening and exhilarating change.

Thus this furniture is both architecture and craft. The architectural qualities of modern furniture are derived above all from the expression of its structural characteristics. The tradition

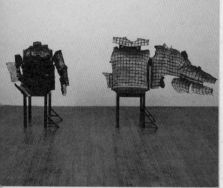

Figure 16
Allan Wexler
Body Furniture, 1991
Courtesy Ronald Feldman Fine Arts,
New York

Figure 17
Karl Arnold Erben
Von der Werkbund-Ausstellung (From the Werkbund exhibition), 1914
Caricature showing from left: the individual chair, the chair-type, and the chair in which one can actually sit

of French furniture called for the subjugation of that structure to layers of finish. The great furniture designers were not makers or fitters, but finishers, of whom the highest were the *ébénistes*. These were the designers who gave the set pieces of classic French furniture their final form. They were geniuses at counterfeit. They could make wood or any other material look like anything and could transform the most basic storage chest into an essay on style and fantasy (see fig. 18).[3] For them, furniture was fashion, both because its appearance changed continually and because it was an extension of the clothing that defined a person's place in society.[4]

In the English and German traditions there was a greater attention to carving, which brought out the innate functional forms, but such expressions were still subjugated to formal concerns. For Sheraton or Chippendale, the forms that brought out the subtle characteristics of their pieces derived from both the conventionalization of motifs and the need for the chair or armoire to express

status (see fig. 19). They made furniture that was specific to a person's construction of a social reality, not just the construction of the body. Design, in other words, was something a furniture designer layered onto a frame whose basic characteristics and construction were already given.[5]

With the advent of modernism as a movement at the end of the nineteenth century, furniture designers felt a need to express the actual function and structure of their pieces. The great theoretician of this movement was John Ruskin, who called for the honest use of native oak and the expression of function in each form.[6] The Arts and Crafts movement, which followed his dicta, did away with most finishes and inlays, replacing them with carving directly into the wood. The Mission style furniture of the United States took this logic all the way to the point of an expressive primitivism.[7] In Germany and Austria furniture designers who grouped themselves in such collectives as the Wiener Werkstätte oscillated between an extreme

lightness (shared by Charles Rennie Mackintosh) that attempted to almost do away with the reality of objects altogether and a monumentality that transformed them into built versions of the trees out of which they had been made.[8]

These developments were also the result of the attempt by designers to reintegrate furniture into the design of the whole environment. Architects such as Henry van de Velde wanted to take over from the specialists in crafts the task of making those objects that filled the spaces they designed. This was not just a theoretical desire: as more and more commissions came from middle-class clients looking for domiciles, architects were threatened by the new classes of decorators and the mass production of furniture. They had to defend their field. Thus modern furniture became a way of pursuing the ideals of modernist architecture in a format that was easier for many to understand and afford, while also precluding the intrusion of older furniture into new houses.[9]

An opposite impulse came from Russian, Dutch, and some German designers, who felt that a necessary revolution in the way people lived their daily lives must take place if they were to act out the logic of the industrial revolution. New materials such as metal, enamels, molded plywood, and compound plastics brought with them the ability to make shapes and finishes that did not fit within furniture traditions. The expansion of activities taking place in everyone's life—the specialization of work, the many distractions thrown up by a consumer culture, the mixing of traditions created by the social upheavals of industrialization—brought with it the need for new forms. The constructivists and members of other movements that influenced the work created at Soviet schools such as the Vkhutein made this need into an opportunity to craft forms that were unfamiliar, startling in their appearance, and destabilizing of the relationship between the body and the environment it inhabited.[10]

Figure 18
Attributed to André-Charles Boulle, with medallions after Jean Varin
Cabinet on a stand, c. 1675–80
The J. Paul Getty Museum, Los Angeles

Figure 19
Thomas Chippendale
Side chair, c. 1760
Fine Arts Museums of San Francisco, gift of Frank Schwabacher, Jr.

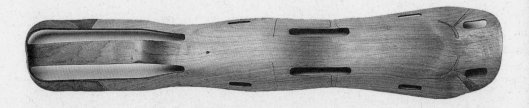

The great synthesis of these various movements took place at the Bauhaus. Its first director, Walter Gropius, inspired by syncretic designers such as van de Velde, developed a complete logic for furniture. The teachers at the Bauhaus felt that furniture should adopt and adapt processes of mass production, elevating them in the tradition of great art and design, while serving a much wider audience. Furniture should be seen as an integrated part of the whole world of design. It should be part of the construction of a better world. It should not only make it easier and more comfortable for somebody to sit but also make visible the same logical principles that were to wrest humankind away from preconceptions, unhygienic conditions, and the tyranny of a social system that imprisoned the many to create the free spaces and luxurious surroundings of the few.[11]

The work that tried to build these beliefs—whether it was produced at the Bauhaus, in other countries by designers trained there, or by architects and designers such as Le Corbusier and Gerrit Rietveld, who followed similar principles—remains at

the core of modernist furniture. The chair Marcel Breuer designed while still a student at the Bauhaus (1922–24; pl. 10), Rietveld's Red/Blue Chair (1918; pl. 8), and also such pieces as Giuseppe Terragni's chair for the Casa del Fascio (1932–36; cat. no. 132) were all constructed markers on the way to a new world.

There were, however, two contradictions inherent in this synthesis. The first was one that Reyner Banham identified in speaking of the architecture of the Bauhaus.[12] It was a conflict in approaches that came out of the tension between a tradition of empirical research that sought to solidify the data or facts of the modern world into new constructions and one that sought to impose a scheme on the old world, so that the new would obliterate the old. In furniture, this was also a tension between objects that were meant to be more logical responses to the needs of the human body, conceived of as a generic abstraction, and those that were solidifications of ideals. These opposing tendencies often followed gender lines. Thus, male architects such as Breuer, Terragni, and Ludwig Mies van der Rohe almost always made furniture that veered in the latter direction, while

it is interesting to note that women designers such as Charlotte Perriand moved in the direction of what one might call experiential collages that considered the needs of the body in new ways.[13]

A second problem arose from the fact that the experiments all of these designers performed produced results that only a very few could afford. The monuments of modern furniture are not necessarily the unique pieces of the *ébénistes*, but they were limited production models. Even after they began to be produced on a larger scale—as was the case with many of Breuer's, Mies's, and even some of Rietveld's pieces, and certainly with the designs of the second-generation modernists in Denmark and Finland—they were still too expensive for all but the most economically well-positioned members of a mass society.

What promised to solve both of these contradictions was plasticity. World War II unleashed an array of different production methods that quickly found their way into the world of furniture. They included first, of course, the

various forms of vacuum-formed and cast plastic that gave designers the freedom to produce a variety of shapes they could have only dreamed of before then. They could make forms that were completely abstract and yet were negative molds of the body, as Verner Panton was famous for doing. They could also produce fragments of geometry that a factory could turn out by the millions—though very few factories actually did.[14]

This freedom of form moved beyond the world of plastics into the realms of bentwood, from which the Thonet factory had been creating objects of high design and low cost for almost a century, and molded plywood. Designers such as Charles and Ray Eames experimented with molded plywood to make leg splints (fig. 20) and chairs, while Alvar Aalto, who had been experimenting with the plywood products produced by Finnish wood companies since the early 1920s, took the spine out of the body, creating a whole bestiary of sensuous curves and turning them into objects that could pose themselves in the most elegant surroundings. Lightweight metals such as aluminum could be pressed into thin sheets with

Figure 20
Charles and Ray Eames
Leg splint, 1942 (cat. no. 32)

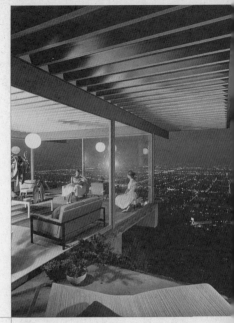

great strength and little weight. The gesture of a designer could suddenly become a structural object.

The 1950s were thus the glory period of modernist furniture, especially in the new world power of the era, the United States. For a few years, between 1947 and 1955, the principles of modernism were something that everyone could afford and were propagated by the organs of mass dissemination, such as the "shelter" magazines, as the most elegant way to live. Not just designers whose names are still recorded in the history books, such as the Eameses and George Nelson, but also many anonymous designers created furniture whose innovative use of new materials, collages of abstract forms, and play between abstract planes and organic shapes built up a whole new universe. Los Angeles's Case Study House program produced ready-made fragments of a domestic utopia that integrated all these innovations into model homes (see fig. 21). In the era of the birth of the sitcom and the arrival of modular clothes made of synthetic fabrics, the

idea that the modular wall unit, the plywood couch, the clock that might look like a constellation, and chairs that were plastic buckets were all-important parts of every American's daily life did not seem so strange. Modernism had triumphed in furniture, as it had in politics and art.[15]

It was not to last. Modernist furniture never had its Vietnam or its Pruitt-Igoe housing development, but it did disappear from department store floors and magazine spreads after about 1965. It became not so much the mark of the elite (except in college towns) as it became what it never thought it could be: an outdated style. It turned out that the belief in furnishing a better world was as time-contingent a notion as rococo or Gothic revival. Modernism became passé, and modernist furnishings became symbols of hubris that most Americans relegated to attics or garage sales.[16]

There they became collectors' items. Now they have been rediscovered and make up the centerpiece of major collections such as that of Michael and Gabrielle Boyd. But what about the mainstream of furniture design? Certainly all designers did not give up and retreat into

historical revivals? No, they sought other ways of justifying the design of furniture that both contained ideals and was meant to reflect the needs of the average body. After one last gasp of synthetic (in both senses of the word) design that imagined Barbarella as the inhabitant of future domiciles—the work of Joe Colombo comes to mind—furniture design joined architecture, literature, philosophy, and—some would argue—politics in the semiotic games of postmodernism. Furniture designers created fairy-tale lands populated by dream pieces whose lack of scale, comfort, or material logic was meant to remind us of the freedom we have as human beings to imagine things that cannot be real. They also built jokes: the Memphis group in particular specialized in making humorous pieces whose titles and forms were more witty aperçus than contributions to the relationship between the body and its environment.[17]

This is also where the collection of Michael and Gabrielle Boyd ends. They prefer collecting the real pieces of the dream to fantasizing about future fun. That does not mean that they

have not sought out those furniture designers who are attempting to find life in the central tenets of modernism. They have, in fact, commissioned works from some of the Bay Area's most innovative designers, such as Daven Joy of Park Furniture (see fig. 2), who are looking for new ways of pursuing the high ideals and simple pleasures of modernist design.

Many of these designers are forming workshops in which they can create limited production pieces that are still relatively affordable. Others are working with larger companies to mass-produce good design. Chain stores such as Ikea are even commissioning young designers to create projects that have all the simplicity, experimental quality, and beauty of some of the great modernist furniture of the period between the world wars. Combined with the current interest in classic modernist pieces, these developments give hope that modern furniture can continue to sit on the edge, showing us new ways to inhabit, feel comfortable in, and rearrange the landscapes of our everyday lives.

Figure 21
Pierre Koenig
Case Study House #22, Los Angeles, 1960

NOTES

26

1. Galen Cranz, in *The Chair: Rethinking Culture, Body, and Design* (New York: W. W. Norton, 1998), discusses the evolution of the chair in terms of status, comfort, and design ideals and sums up much recent research on ergonomics, bringing it into relation with design history.

2. The notion of building a better world has always been central to modernist design. According to writers such as Manfredo Tafuri, the utopian impulse has been crucial to the architect's role since at least the Renaissance (see Tafuri's *Architecture and Utopia: Design and Capitalist Development*, trans. Barbara Luigia La Penta [Cambridge: MIT Press, 1976]). Though others do not place so much importance on the notion of building a perfect world, there can be little doubt that the most significant movements in twentieth-century architecture—from constructivism through the early work of Le Corbusier and the work coming out of the Bauhaus to the post–World War II ideals of CIAM and Archigram—have all gained their power from the belief in the construction of utopia.

3. The relationship between fashion and form was beautifully explored by Mario Praz in *An Illustrated History of Interior Decoration from Pompeii to Art Nouveau* (London: Thames & Hudson, 1981), esp. 65–67.

4. For an overview of French furniture of the period, see Alexandre Pradère, *French Furniture Makers: The Art of the Ebéniste from Louis XIV to the Revolution*, trans. Perran Wood (Malibu, Calif.: J. Paul Getty Museum, 1991). See also Fiske Kimball, *The Creation of the Rococo Decorative Style* (New York: Dover Publications, 1980).

5. The best survey of this furniture is still Peter Thornton's *Seventeenth-Century Interior Decoration in England, France, and Holland* (New Haven: Yale University Press, 1978). See also John Gloag, *The Englishman's Chair: Origins, Design, and Social History of Great Furniture in England* (London: Allan & Unwin, 1964).

6. Ruskin argued all his life for honesty in all aspects of the arts but in 1859 published a book, based on a lecture of that year, which became the most popular tract on decoration in both the United States and England. He was not alone, however; Charles Eastlake, Owen Jones, and other advocates of design as a form of revelatory art also influenced the emergence of the Arts and Crafts movement. See John Ruskin, "The Two Paths in Art; Being Lectures on Art, and Its Application to Decoration and Manufacture, Delivered in 1858–9," in *The Works of John Ruskin*, vol. 12 (New York: John Wiley & Sons, 1879). See also Fiona MacCarthy, *William Morris: A Life for Our Time* (New York: Alfred A. Knopf, 1995).

7. The Mission style was itself an adaptation of the furniture produced by workshops like those of Gustav Stickley in New York, but it connected to a sense of agrarian utopianism in California, as well as to the styles of cultures that were seen as both indigenous and "exotic" (i.e., Japanese, Chinese, and Mexican). See Kenneth R. Trapp, *The Arts and Crafts Movement in California: Leading the Good Life* (New York: Abbeville Press, 1993).

8. A recent exhibition on Mackintosh has made his work once again readily available to the public; see Wendy Kaplan, ed., *Charles Rennie Mackintosh* (New York: Abbeville Press, 1996). See also David Brett, *C. R. Mackintosh: The Poetics of Workmanship: Essays in Art and Culture* (Cambridge: Harvard University Press, 1992); Jane Kallir, *Viennese Design and the Wiener Werkstätte* (New York: George Braziller, 1986); and Werner Schweiger, *Wiener Werkstätte: Design in Vienna, 1903–1932* (New York: Abbeville Press, 1990).

9. Adolf Loos was a tireless advocate for looking at furniture in relation to both fashion and manufacture and not as a subset of architecture. His essays on the subject are collected in *Spoken into the Void: Collected Essays, 1897–1900*, trans. Jane O. Newman and John H. Smith (Cambridge: MIT Press, 1982). Gwendolyn Wright was the first to unearth the great lengths to which architects went from the latter part of the nineteenth century on to defend themselves from craftspeople and women, who they felt were invading their turf; see *Building the Dream: A Social History of Housing in America* (Cambridge: MIT Press, 1983).

10. Selim O. Khan-Magomedov, *Pioneers of Soviet Architecture*, trans. Alexander Lieven (New York: Rizzoli, 1987), 61–73.

11. Walter Gropius, "Principles of Bauhaus Production," and "Programme of the Staatliches Bauhaus in Weimar," in *Programs and Manifestoes of Twentieth-Century Architecture*, ed. Ulrich Conrads, trans. Michael Bullock (Cambridge: MIT Press, 1970), 45–49, 95–96. See also Howard Dearstyne, *Inside the Bauhaus* (New York: Rizzoli, 1986).

12. Reyner Banham, *Theory and Design in the First Machine Age* (London: Architectural Press, 1960). Banham traces the division back to a split in teaching methods at the École des Beaux-Arts in Paris.

13. I explored the ways in which women brought different perspectives to twentieth-century design in my *Building Sex: Men, Women, and the Construction of Sexuality* (New York: William Morrow, 1995). Authors such as Beatriz Colomina and Sylvia Lavin have also done valuable, though still largely unpublished, work in this area.

14. For the relationship between trends in American culture and industry and the development of the artifacts of everyday life, see Jeffrey Meikle, *American Plastic: A Cultural History* (New Brunswick, N.J.: Rutgers University Press, 1995).

15. For a moving memory of this era, see Peter Blake, *No Place like Utopia: Modern Architecture and the Company We Kept* (New York: W. W. Norton, 1993). For the most recent compendium of essays on the work of the Eameses, see Donald Albrecht, ed., *The Work of Charles and Ray Eames: A Legacy of Invention* (New York: Harry N. Abrams, 1997).

16. The most notorious account of the modernist fad and its fading is Tom Wolfe, *From Bauhaus to Our House* (New York: Farrar, Straus & Giroux, 1981).

17. Barbara Radice, *Memphis: Research, Experiences, Results, Failures, and Successes of New Design* (New York: Rizzoli, 1994).

THRONES | FOR THE COMMON MAN

Just when we think that the world does not need another chair, a brand-new one is on the horizon. Designers will never get enough, and neither will the rest of humankind. Anyone asked to come up with an example of good design is likely to pick either a car or a chair, because those are the objects that seem to embody everybody's conscious experience of design.

In a designers' life, however, the chair is also a ritual of initiation. While lighting fixtures are often approached as poetic gestures and can thus represent a designer's degree of artistic freedom, the conception of the first chair represents the first true mature challenge. Chairs teach designers about imperfect control, as each one is a sphere where real freedom exists only within very defined boundaries. As chairs are, first and foremost, meant to accommodate people, heaven—the design idea—and earth—the process of making things—have to come together and highlight design's sublime unit of measure, the human body and soul. This is why the designer needs to leave his godliness behind, yet he cannot even rely on the more mundane

aspects of design, such as materials and techniques of craftsmanship, as a guide through this difficult process of creation. In chairs, more than in any other designed object, human beings are clearly the unit of measure that everything has to defer to, including economic considerations such as manufacturing and marketing. While designing a chair, even one that never gets beyond the prototype stage, one has to measure oneself against the rules and regulations of the body and thus get a taste of what design is all about—a stringent reality check. And the reality check, once started, continues all the way through economic, engineering, and marketing considerations.

Chairs are omnipresent in the history of design, so much so that they can be used as keys to an extended narration of its events. They can be considered as symbols of historical moments in the evolution of society and evaluated for their capacity to fully represent their times. Or they can be appreciated as technical or artistic objects. Many books have explored chairs from all different angles. Two recent volumes take very different approaches. Charlotte and Peter Fiell's *One Thousand Chairs* is a voluminous "who's who" of chair

design from the nineteenth century up to our days, and it is organized chronologically. The authors declare that the examples that they have selected share a "powerfully argued rhetoric" that, in their words, "sets them apart from the vast majority of other chairs."[1] In other words, the one thousand chairs have been chosen because of their relevance within design history, although the high numeric goal barely allows for a selection but instead requires a collection. Mel Byars, by contrast, in *Fifty Chairs*, selects chairs according to their relevance as manufactured objects.[2] He limits his field of interest to the last few years and analyzes the way chairs are made as a way of revealing a more general shift in the role that design has in the world today. Both books have a valid place in the literature.

Any kind of unilateral analysis of design, however, whether formalist or strictly sociological, whether inductive or deductive, tends to strip it of some important information. Connected as it is to visual culture, technology, and economy at any given time, design is first and foremost a

Figure 22
Film still from *Kaleidoscope Jazz Chair* (1960) showing Charles and Ray Eames

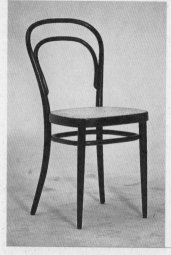

social activity, especially since the advent of industrialization. Italian designer Ettore Sottsass, an astute interpreter of his own times, says design "is a way of discussing society, politics, eroticism, food and even design. At the end, it is a way of building up a possible figurative utopia or metaphor about life."[3] The British architect Peter Smithson carries this argument even further: "It could be said that when we design a chair, we make a society and city in miniature. Certainly this has never been more true than in this century. . . . It is not an exaggeration to say that the Miesian city is implicit in the 'Mies' chair."[4]

In the design of chairs, at different times some designers have embraced reality, and therefore social needs and economic considerations, while others have opted for a more immediate representation of a new, revolutionary aesthetic and moral ideal, however uncomfortable. Some chairs, like Ludwig Mies van der Rohe's or Le Corbusier's, existed to communicate a global architectural idea, rather than simply to provide a support for the human body. Memorable and expensive, these iconic chairs are usually known by the educated masses, ignored by the mainstream market, and

adored by the critics. They have punctuated the history of design and have often carried the manifesto of a current or historical trend. From Gerrit Rietveld's Red/Blue Chair of 1918 (pl. 8)—which, together with Piet Mondrian's paintings, has become the emblem of the De Stijl movement—to Marcel Breuer's Wassily Chair (1925; fig. 13), to Verner Panton's stacking chair (1960; pl. 95), up to Marcel Wanders's Knotted Chair of 1995, which characterizes a new era in the use of materials, objects of such intrinsic intensity have managed to obliterate the functional world around them and rise to what is considered by some the zenith: art. And in fact they are sublime. Only we are left with the feeling that an even higher place does exist, where reality and genius are brought together, and that is still called design.

There were indeed a few crucial moments in the history of chairs when great, iconic design by renowned masters was able to meet the demands of the mainstream market, generating at last a series of the thrones for the common man. Examples of such ideal design products are not many, but their magnitude can be

easily acknowledged. For example, the Thonet no. 14 chair of 1859, Hans Coray's Landi Stacking Chair of 1938, the Eames fiberglass chairs of 1948–50, Arne Jacobsen's model 3107 chair of 1955, and Giancarlo Piretti's Plia Chair of 1969 are all considered masterpieces of design, but they were all born as utilitarian objects. They were designed to be widely usable and marketable. They generally exploited either a new industrial technique or the materials that were typical of their region and their time—be it bentwood, plywood, aluminum, fiberglass, or ABS. Their price was sensible, their form elegant and contemporary, and their image unthreatening and gratifying to their prime audience, the middle class. Each one of them indeed enjoyed a universal popularity, in most cases still alive today. Each one was as powerful and ubiquitous as anonymous design, recognizable also by those who do not know what *design* means. And, most of all, each one was copied or imitated innumerable times, generating an ever-growing family of similar chairs that

pervade the mainstream market.

While this listing of outstanding popular chairs, the thrones for the common man, will be limited to the industrial age, many chairs of similar historical intensity can be found even before the nineteenth century. Any meaningful vernacular chair will do. The eighteenth-century Shaker chairs, for instance, display a sobriety and honesty that were a direct reflection of the circumstances that generated them. The choice of materials—wood and wicker—was dictated by availability, and the materials were used according to their capabilities. Every detail of the ultimately beautiful chair served a practical purpose. As a matter of fact, in the introduction to *Shaker Built*, Paul Rocheleau and June Sprigg state: "The Shakers' attitude towards their buildings was no more sentimental than their attitude about their own flesh-and-blood bodies. It was the spirit of usefulness within that mattered, not the vessel itself."[5]

In the industrial world the first great universal chair was the Thonet no. 14 of 1859 (fig. 23), which features the same economy of means as the Shaker chairs but matches it with an embryonic industrial effort, offering a

Figure 23
Michael Thonet
Chair, model 14, 1859

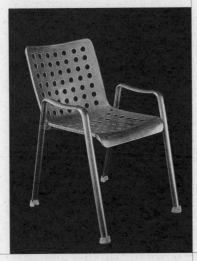

profit-making logic in place of the Shakers' moral standpoint. Michael Thonet patented an innovative mechanized process for steam-bending wood, which he had been perfecting since 1830, and opened his factory in Vienna in 1853. "Thonet's technique was indeed revolutionary: machine-formed rods of wood, usually beech, were curved and bent under steam pressure and screwed together, completely eliminating the need for jointing or sockets."[6] The machine-bent wood provided a standardized and low-cost way to the decorative effect the Mitteleuropean bourgeoisie still craved. Thonet's furniture was at the same time organic and industrial, an elitist-looking product at a popular price. Although the no. 14 was only one of the many items in the Thonet line, and the others were much more eclectic and elaborate, Thonet's rationalization of society's needs led to one of the first examples of the balanced aesthetic use of an industrial process.

The early twentieth-century avant-gardes translated the possibilities of the mechanized process of manufacture into a number of iconic chairs that set the direction for the future of design in the consumer market. The modern movement, in particular, provided the language that is still in use today. The efforts of European modern architects and designers such as Mies, Breuer, and Alvar Aalto—with their use of tubular steel or sleek, molded laminated wood, finished with thin upholstery—reduced the shape of furniture to the minimal proportions that are still employed today.

The modern movement failed, however, to connect itself with industry. The next European throne appeared outside those official circles, although its success was decreed in part by the modern masters. Walter Gropius and Le Corbusier were among the jurors for a 1938 Swiss competition that was won by Hans Coray, a student of Romance languages and self-taught designer. The competition called for new outdoor chairs to furnish the Swiss parks. The chairs were to be made of the national metal, aluminum. Coray's chair (fig. 24) became the official chair of the 1939 "Landi," the Swiss national exhibition. The fruit of a collaboration between the designer; the architect of the exhibition, Hans Fischli; and the P. & W. Blattmann Metallwarenfabrik, the chair weighed only three kilos (6.6 lbs.). It was a synthesis of technologies borrowed from the aeronautics industry and from the Swiss Federal Railway, and its manufacturing process required a three-hundred-ton drawing press. Its seat was made of aluminum perforated in such a way as to make the chair very light and at the same time exceptionally sturdy.[7] The chair was a real industrial product, in typical Swiss spirit, and its sensibility was easily translated in the many derivative seating designs that were later produced worldwide.

Back in the United States, it is not until after the end of World War II that we encounter another real throne for the common man. With the vast amount of new technology developed for the war effort ready to be transferred into civilian use, the times were ripe for a real joint effort by design and industry. Despite a few sporadic prior examples of full-fledged designers, such as Peter Behrens and Raymond Loewy, design became a profession in its own right only after 1945,

Peter Dormer has rightly argued.[8]

Charles and Ray Eames, the most fascinating team in design history, designed the next crucial example, their fiberglass chair (see fig. 22). The extended narrative of its development provides a crystalline description of the qualities of such universal chairs. The Eameses were unique in their ability to represent the common man, or the common child, in any object that they designed. The tools of their creativity were as extensive as the range of their products. Their partnership brought about a new and constructive solidarity between art, science, and design, making it available to the masses. In their minds, reality was a gigantic catalogue of images, techniques, and shapes, a catalogue of platonic ideas. Each idea was an entity, a character. As designers, they would borrow these characters with ease to compose possible alphabets, then words, and then phrases that their talent would make poetic and enlightening. Yet the exceptional character of their work lies in their capacity to make this language universal. Their furnishings, architecture,

Figure 24
Hans Coray
Landi Stacking Chair, 1938
The Museum of Modern Art, New York,
gift of Gabrielle and Michael Boyd

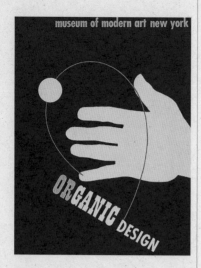

films, and slide presentations, the outcome of a very passionate and meticulous process of composition and synthesis, spoke a language that could be understood by a very large audience.

The history of their universal design starts early, when they had not yet become a team. In 1940 the Museum of Modern Art in New York launched the competition "Organic Design in Home Furnishings" (see fig. 25). According to the museum's ideal, newly designed furniture was supposed to reflect the social, economic, technological, and aesthetic tendencies of its time and be geared toward innovation. Designers and manufacturers were supposed to spark a revolution in the way people lived by generating ideas for furniture that was really responsive to human bodies. Charles Eames won, together with Eero Saarinen. The two designers came from the Cranbrook Academy, the famed Michigan Bauhaus founded by Saarinen's father, Eliel. The jury for the competition was outstanding, composed as it was of Aalto, Breuer, Alfred Barr, Frank Parrish,

and Edward Stone. Eames and Saarinen participated with an armchair, a side chair, a high-backed chair, and a sofa, made of molded laminated wood and subtly upholstered. Charles and Ray moved together to Los Angeles and continued the experiments with molded laminated wood. Legend has it that the first prodigious "Kazam!" machine, capable of bending the wood in two directions, was kept in their apartment in Westwood. In a few months the production went from domestic to industrial, first with the Evans Products factory and then with the Herman Miller Furniture Company at its Michigan plant. In March of 1946 the furniture was the subject of a solo show at the Museum of Modern Art, entitled *New Furniture: Designed by Charles Eames*.

However beautiful, innovative, sensible, and universal it may have been, the wooden furniture of 1946 could not anticipate the ubiquitous success of the plastic chairs the Eameses started to develop around 1948. In 1947 the Museum of Modern Art launched another competition, this one entitled "Low-Cost Furniture

Design," with the intent of boosting the production of low-cost, mass-produced home furnishings. The perspective was this time even wider, with an eye to "the national economy and the general welfare of the peoples of all countries," the catalogue reports. The goal was to build a better society and better lives after the long wartime years, and designers were considered instrumental in improving the environment. Charles and Ray Eames received second prize. "Although the Eameses also submitted a design for a chair made of fiberglass-reinforced plastic, the actual intention was to make the chairs using varnished or Neoprene-coated steel or sheet aluminum. . . . In the eyes of the jury, which included Ludwig Mies van der Rohe, making seating furniture out of sheet metal held promise as a method of mass production, and had even proven useful in the automobile industry."[9]

The competition was based on drawings and plaster models, and the winners were asked to produce prototypes for a future exhibition. Right at that time, three representatives from a California-based company called Zenith Plastics visited the Eameses in their office to introduce them

to fiberglass, a material developed during World War II for use on the noses of airplanes as a casing for radar equipment. The designers adapted the shapes to the new technology and found an ingenious way to attach the plastic shells to different types of metal bases. The organic shapes of the mass-produced plastic furniture recalled the very first models Eames and Saarinen conceived in 1940. The ubiquitous stacking chair—whose shape recurs everywhere, in stadiums and cafeterias alike—was first produced in 1955.

The place and time of this throne's appearance are no accident. California modernist design and architecture centered their action on society. While the trademark European movement of the 1930s relied heavily on ideology, West Coast modernism, based as it was on a straightforward and optimistic realism, was the champion of American sensibility and idealism. The new architecture "for modern living" established itself after World War II as a way to represent and accommodate the booming middle class in an innovative residential model, all the while using the materials and techniques made

Figure 25
Organic Design in Home Furnishings by Eliot F. Noyes; cover design by E. McKnight Kauffer
Published for the Museum of Modern Art by Arno Press, 1941
Collection of Michael and Gabrielle Boyd

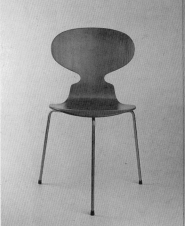

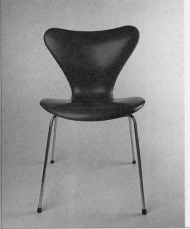

available by the idle war industries that were based in the area. The Californian way of design and architecture was about practice, not about theory, and it required that homes be comfortable and efficient, both in the way they were used and in the way they were built. Most peculiarly, since design was aimed at the home, its guidelines were forged by the domestic sensibility of its inhabitants, chiefly women. Utility was the guiding principle and the key to a new aesthetic that became the official American "good taste," a taste that was born out of economy.

Charles and Ray Eames fit comfortably in this spirit. All their production apparently stemmed out of necessity, from the low-cost, affordable, sensibly beautiful furniture to their efforts to divulge the secrets of science and technology through exhibitions. And their furniture turned out to be truly revolutionary because of the way it penetrated the market and reached a wide public. With their low-key approach, Charles and Ray unconsciously played an important political role in the postwar culture, as their chairs

have become part of America's material culture. As is typical of all thrones for the common man, they are as famous as some anonymous designs or as a few branded products. The Eameses' chairs are an outstanding contribution toward an autonomous American way to architecture and design, and their effect can be measured to this day in the self-confident design methods used by several professionals. With their universal and original language they were able to give the world, especially the American world, a body of useful neologisms to build upon.

Meanwhile, in the Old World, the understated Scandinavian tradition produced a chair that is to this day among the most quoted, often with the help of copies, in minimalist restaurants, tony cafes, and hip conference rooms worldwide. The Danish designer Arne Jacobsen undertook a manufacturing process that was new for his country and similar to that used by the Eameses in their plywood furniture. The process enabled him to mold layers of plywood in an effective and solid way to form a unique seating

shell, to be positioned on tubular steel legs. The first chair, the famous Ant, was designed in 1952 and was supported by three legs only (fig. 26). It is nonetheless the later 3107 model (1955; fig. 27), with its simpler shape and four legs, that enjoyed the most success. It is still produced in a vast array of colors and thus provides an easy solution for a decorative yet modernist effect. Like most thrones for the common man, it appears to be appropriate everywhere.

During the 1960s, at the time when Victor Papanek was writing *Design for the Real World* (first published in 1971),[10] many throne attempts were sighted all over the world. Idealism was then at a high pitch, and the common man was almost idolized. The new materials available, thermoplastics and polyurethane foam, seemed suitable for real, all-around mass production, at last. Yet a necessary characteristic of truly universal chairs is a somewhat traditional flavor. The seat is usually molded or shaped, yet it is supported by distinct legs, just like the most conservative chairs. However innovative the materials or the techniques, universal chairs have to be able to appeal to a common denominator. Many

great democratic attempts, like Panton's 1960 stacking chair or Joe Colombo's 4867 (1967), were just too edgy for the popular taste and therefore cannot enter our firmament. Yet it is thanks to these attempts that Piretti was able in 1969 to design the Plia (fig. 28), which became the Eames chair of Italy in the 1970s and is still in production today. Both stackable and foldable, the *Plia* is made of steel and acrylic. It is both modern and comfortably domestic. The structure is made of oval-in-section tubular steel, with one part forming the back support and the front legs, another the back legs, and a third the seat. The three parts are held together by a beautifully designed joint made of three metal disks, an innovation. So widespread and constant was the use of the chair that the manufacturer, Anonima Castelli, had to provide a spare-parts service to replace the acrylic seats and backs, which would promptly crack after about five years of continuous use, lunch after lunch, dinner after dinner, day in, day out.

Figure 26
Arne Jacobsen
Ant, model 3100, 1952
Collection of Michael and Gabrielle Boyd

Figure 27
Arne Jacobsen
Series 7, model 3107, 1955
Collection of Michael and Gabrielle Boyd

Figure 28
Giancarlo Piretti
Plia Chairs, 1969
The Museum of Modern Art, New York.
Gift of the manufacturer, Anonima Castelli, .
Italy

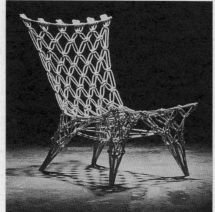

Curiously enough, it is hard to find another universal throne after that date, and the reasons need to be explored. The energy crisis and the polemical spirit of radical design in the 1970s did not favor the common man. Neither did the egocentrism and the redundancy of 1980s design. The attempts made in the booming contract furniture industry, albeit economically successful, have not been able to attain the unity of function, aesthetic, and availability typical of the previous examples. After all, an office is not a home, and the universality of some office chairs was almost forced upon their users. Even though ergonomics has tried to adapt the furniture to the human body, the soul of design has been temporarily lost.

The late 1990s, by contrast, are peculiarly similar to the second postwar period. These are spiritual times, marked by a renewed attention to domestic living and fueled by concerns about the environment and by a strong polit-ical consciousness worldwide. Design trends are often accurate reflections of social change, and the economy and sensibility that envelop the world today after an age of excess are very strong forces indeed. Morality, sometimes even moralism, is a recognizable feature of many contemporary objects. In good recent design, ethics are as important as aesthetics. All in all, contemporary design is frequently experimental in its use of materials and often inspired by genuine necessity. Even so, it sustains elements of surprise and deep intellectual beauty because it relies more on invention and reduction than on the elaboration of previous styles. It is a good time for design.

Things will nonetheless never be the same, and progress is either to blame or to praise. We might not see another throne for the common man again, or we might see hundreds, all at the same time, diversified by location and market. Nothing can be truly universal in the postindustrial furniture world, a world where very high technology coexists in a peaceful synergy with very low technology and where diversifica-tion is embedded within the industrial production series. Experimentation requires a hands-on approach, and the flexibility and novelty of the materials and manufacturing methods available today have stimulated the explo-ration of numerous possibilities. Advanced materials, such as the aramid fibers of Marcel Wanders's Knotted Chair, can be customized and adapted by the designers themselves (fig. 29). The whole idea of standard has been revolu-tionized and left up to the designer. After decades of debates about the meaning of diversity, the new means of communication and connection have changed our perspective. We can count on a world that has learned and digested a new idea of universality and discretion, in furniture, literature, fashion, religion, and music alike. It is time for universal concepts, not for universal chairs, and the common man does not need a throne anymore.

NOTES

1. Charlotte and Peter Fiell, *One Thousand Chairs* (Cologne: Benedikt Taschen, 1997), 16.

2. Mel Byars, *Fifty Chairs* (Crans-près-Celigny, Switzerland: Rotovision, 1997).

3. In Peter Dormer, "What Is a Designer?" in *Design since 1945* (London: Thames and Hudson, 1993), 10.

4. In A. Bruchhäuser, *Der Kragstuhl: Stuhlmuseum Burg Beverungen* (Berlin: Alexander, 1986), 86.

5. Paul Rocheleau and June Sprigg, *Shaker Built* (New York: Monacelli Press, 1994), 10.

6. John Heskett, *Industrial Design* (London: Thames and Hudson, 1980), 43.

7. A. von Vegesack, P. Dunas, and M. Schwartz-Clauss, eds., *One Hundred Masterpieces from the Vitra Design Museum Collection* (Weil am Rhein: Vitra Design Museum, 1995), 34.

8. Dormer, "What Is a Designer?"

9. Von Vegesack et al., *One Hundred Masterpieces*, 150.

10. Victor J. Papanek, *Design for the Real World: Human Ecology and Social Change* (New York: Pantheon Books, 1971).

Figure 29
Marcel Wanders (Wanders Wonders)
Knotted Chair (Droog Design), 1996

PLATES

with texts by Michael Boyd, Philippe Garner, and Melanie Ventilla

1900–1925 PIONEERING THE MODERN MOVEMENT The initial twenty-five-year span of the Boyd collection traces the story of modernism from its first clear manifestations in the early years of the new century to its apotheosis in the newly relocated Bauhaus at Dessau. This, broadly, is the story whose linear, evolutionary plot was first charted, and to such lasting effect, by historian Nikolaus Pevsner in his seminal *Pioneers of the Modern Movement from William Morris to Walter Gropius*, published as a near-firsthand report from the front in 1936. Pevsner traced the origins of the modern movement back into the nineteenth century.

The first exponents of modernism had defined the movement by their rejection of historicism and by their desire to reconcile the role of the designer with the machine and industrial manufacture. The British-led Arts and Crafts movement had emphasized values that were absorbed into the modernist charter: truth to materials, rational and evident structure, form following function, and the rejection of decorative ornamentation. The Arts and Crafts movement, however, passionately defended traditions of handcraft and was unable to reconcile this concern with the growing demands of an industrialized consumer society. Modernism was founded on the socialist ideals—rather than the romantic, high-quality creations—of William Morris and on the practical experiments of a generation of engineer-architects and industrial designers who gave convincing form to the utopian visions of the new century.

From Joseph Paxton's Crystal Palace of 1851 to Gustave Eiffel's eponymous tower of 1889 to Robert Maillart's reinforced concrete span bridges (such as his Tavenasa Bridge of 1905), new aesthetic solutions were the product of new technical possibilities. In the United States Frank Lloyd Wright exploited new engineering and structural opportunities in his 1904 Larkin Building, creating an archetype of the modern movement tower with its soaring multistory atrium. Josef Hoffmann designed his Purkersdorf Sanatorium in 1904–5 and established a template for a style of architecture, all white planes and clean grids, which became widespread after 1925. Peter Behrens, meanwhile, was laying the foundations of Germany's international influence in industrial design through his teaching and his subsequent employment with AEG.

After World War I Italian futurism, Russian constructivism, international Dada, and other revolutionary strands in the fields of art and design breathed a new urgency into the search for standards relevant to the century. From the wreckage of imperial Germany emerged a fragile new democracy, the Weimar Republic. This government sponsored the foundation in 1919 of an idealistic new school of art and design, the Bauhaus, under the leadership of Behrens's pupil, Walter Gropius. The Bauhaus staged its first major exhibition in 1923. Two years later, in the school's experimental workshops, Marcel Breuer was to distill design and engineering practice into the first of his revolutionary and emblematic tubular steel furniture pieces.

—P.G.

1903

plate 1

BEHReNS

PETER

SIDE CHAIR FOR THE HOUSE
OF THE POET RICHARD DEHMEL,
HAMBURG

SIDE CHAIR FOR THE LARKIN COMPANY ADMINISTRATION BUILDING

Frank Lloyd Wright designed this all-steel side chair for the administrative offices of the Larkin Company (a manufacturer of mail-order soap products) in Buffalo, New York. Wright claimed that the furniture for this project was the first-ever all-steel office furniture; in any event, it seems to be the first that honestly and clearly stated the unadorned material out of which it was made. The steel employed in nineteenth-century predecessors paraded as other, more refined materials (such as bentwood or fin-de-siècle decorative wrought iron).

In fact, the Larkin building was a Wright project out of which came many firsts—all with an eye toward ease of operation and maintenance. What Wright called an "automatic chair-desk" was another version of this chair, hung from a desk on adjustable steel pivots. The chair could swing into the opening of the desk for storage and expose the floor space. The hundreds of "automatic chair-desks" in the building were a tremendous timesaver for the cleaning and maintenance personnel. Wall-hung toilets, now ubiquitous in the commercial architectural landscape, were first used in the Larkin building. (Unfortunately, no patent was taken, as was common with Wright, according to his son, John Lloyd Wright.) Wright claimed to have been the first to use a partition wall hung from above, also in this building.

The unornamented, rectilinear design of the Larkin Building chair was contemporaneous with the work of Austrians Josef Hoffmann, Koloman Moser, and Otto Wagner, but it certainly predated the seminal Dutch work of a decade later. In fact, the architects of the De Stijl group—Robert van 't Hoff, J. J. P. Oud, and Gerrit Rietveld—had access to reproductions of Wright's work (mostly in German progressive architectural publications starting around 1905) and were ardent admirers of his strongly horizontal Japonesque vision. It was one of the rare instances in which an early twentieth-century avant-garde European art movement specifically cited the work of an American as a significant influence.

—M.B.

FRANK LLOYD **WRIGHT** **1902-6**

SIDE CHAIR FOR
THE LARKIN COMPANY
ADMINISTRATION BUILDING,
BUFFALO, NEW YORK

plate 4

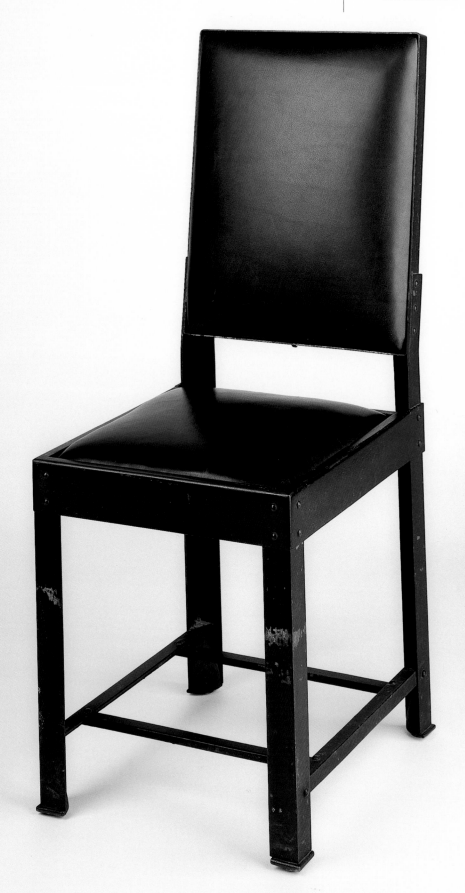

BY BEAUTY WE UNDERSTAND THE HIGHEST DEGREE OF PERFECTION. FOR THIS REASON IT IS
COMPLETELY OUT OF THE QUESTION FOR ANYTHING IMPRACTICAL TO BE BEAUTIFUL. THE FUNDAMENTAL
REQUIREMENT FOR ANY OBJECT THAT WOULD LAY CLAIM TO THE DESIGNATION "BEAUTIFUL" IS
THAT IT NOT VIOLATE THE BOUNDARIES OF FUNCTIONALITY. OF COURSE, THE FUNCTIONAL OBJECT BY ITSELF
IS NOT BEAUTIFUL. THERE IS MORE TO IT THAN THAT. A CINQUECENTO THEORETICIAN OF ART PROBABLY
EXPRESSED IT MOST PRECISELY. HE SAID, "AN OBJECT THAT IS SO PERFECT THAT ONE CAN NEITHER ADD TO IT
NOR TAKE AWAY FROM IT WITHOUT HARMING IT IS BEAUTIFUL. ONLY THEN DOES IT POSSESS THE MOST
PERFECT, THE MOST COMPLETE HARMONY."

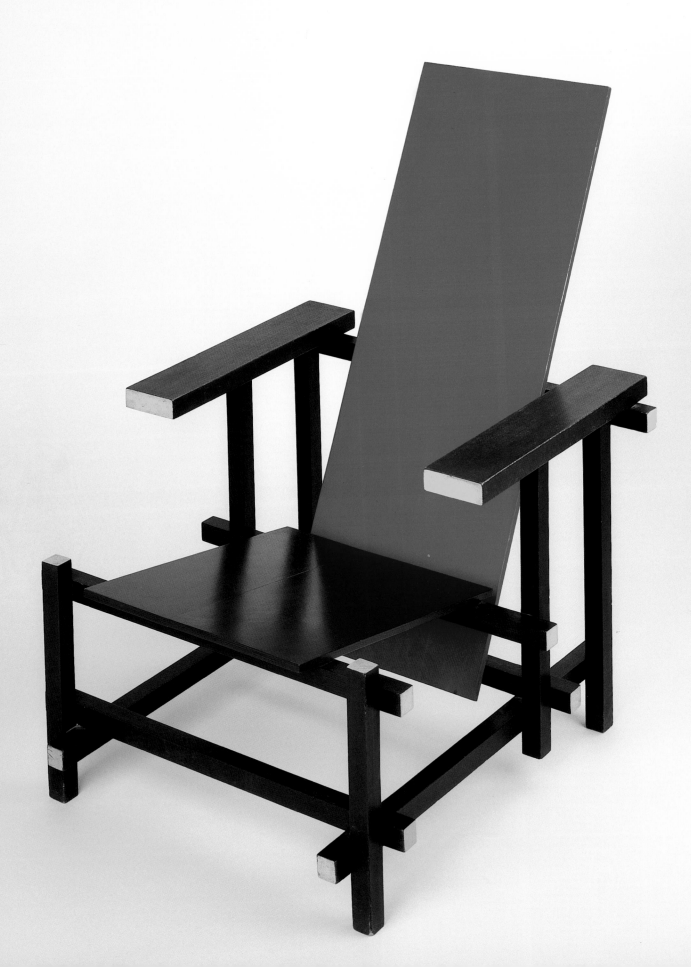

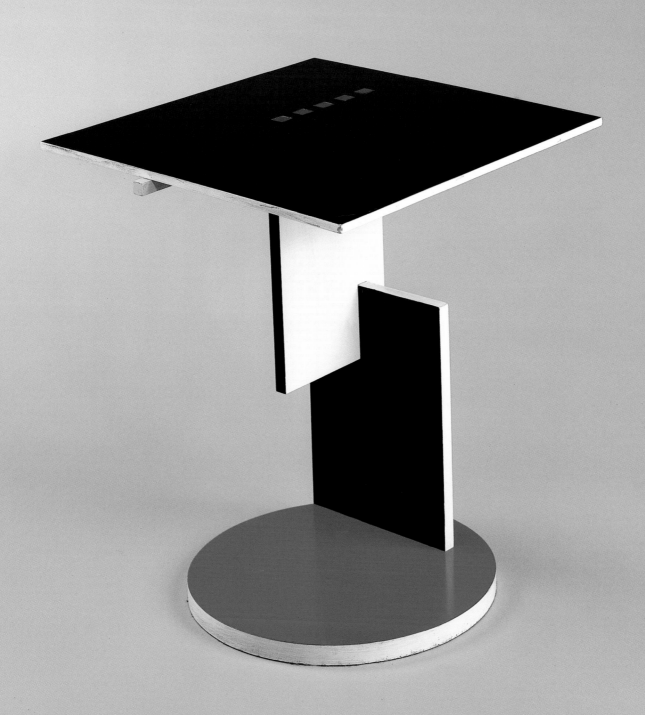

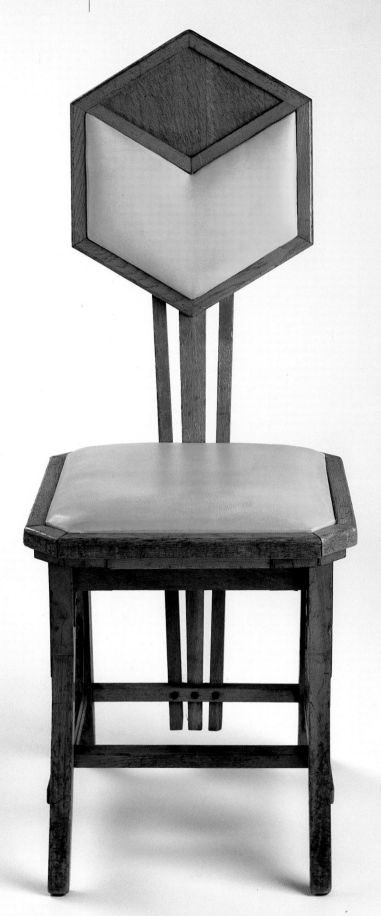

1925–45 MODERNISM COMES OF AGE Marcel Breuer's 1925 Wassily armchair was a design of breathtaking imagination, functioning as a highly intelligent application of new technology in the use of tubular steel and well worthy of its dedication to artist Wassily Kandinsky by virtue of its aesthetic triumph as a piece of sculpture. The Dutch designer Mart Stam had worked independently with tubular steel at the same time, but Breuer's program, including subsequent cantilever designs, enjoyed greater influence. His furniture became one of the most visible products of modernism. Here was a radically new aesthetic. The modern movement was now identified with a highly recognizable style—minimalist, cool, and sophisticated. Ludwig Mies van der Rohe, the last director of the Bauhaus, was to be its most obsessive aesthetic purist, credited with such memorable aphorisms as "Less is more" and "God is in the details." The Boyd collection enters, in 1925, the period of maturity and significantly increased influence of modern movement ideas.

The Pavillon de l'Esprit Nouveau at the Paris 1925 Exposition des arts décoratifs et industriels modernes provided a significant demonstration of modernist thinking within this spectacular but predominantly conservative exhibition. The pavilion was designed as a beacon of clarity and functionalist simplicity by architect Le Corbusier. This, and a few other exhibits, such as Robert Mallet-Stevens's Pavillon du Tourisme, demonstrated that a growing number of designers in France were working along lines very similar to those of the German and Dutch avant-gardes. The modern movement represented an international spirit, a utopianism without boundaries.

The Bauhaus was closed down in 1933 under pressure from a repressive Nazi regime. As a result, certain key figures emigrated, principally to the United States, bringing their ideas and influence directly to new audiences. Breuer's brief sojourn in Britain, for example, gave a quantifiable boost to like-minded British architects and designers. The most significant relocations, however, were those of Lászlo Moholy-Nagy and Mies van der Rohe to Chicago. There Moholy-Nagy founded the New Bauhaus, and Mies opened an architectural practice that was to pioneer an era of steel and glass tower construction that changed forever the concept of the modern city. In 1938–39 New York's Museum of Modern Art staged a major exhibition on the work of the Bauhaus from 1919 to 1928, reflecting and encouraging the lasting influence of the school on the American design scene.

Finnish architect Alvar Aalto, meanwhile, in the context of his Paimio Sanatorium project of 1929–33, created a line of laminated and shaped plywood furniture that proposed a warmer and more gently contoured interpretation of modernism. He effectively defined the Scandinavian approach that was to have so wide an impact after World War II.

The war years were devoted to intensive technical experiment and research. Issues of theory and style were largely irrelevant, and the modern movement experienced a hiatus. After 1945 the political ruptures of the war created a new world map of design influence, with the United States, Scandinavia, and Italy destined to play more important roles.

—P.G.

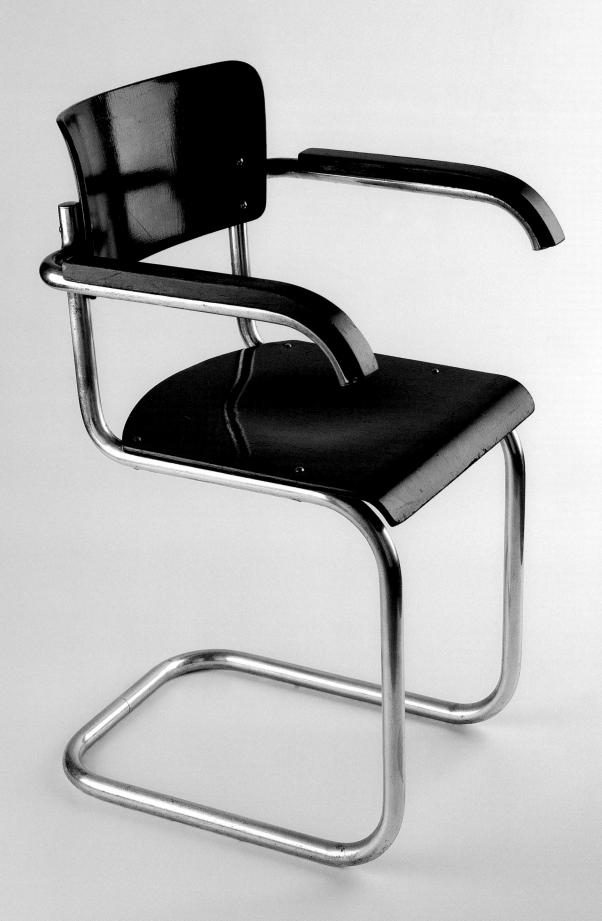

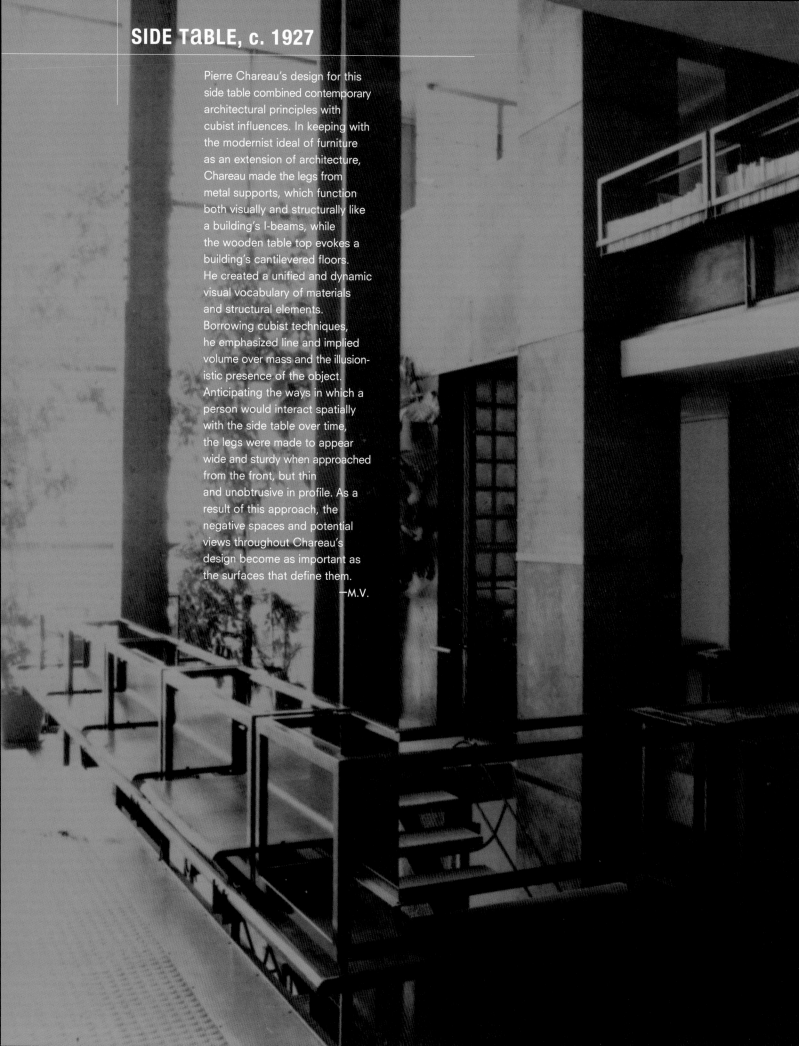

SIDE TaBLE, c. 1927

Pierre Chareau's design for this
side table combined contemporary
architectural principles with
cubist influences. In keeping with
the modernist ideal of furniture
as an extension of architecture,
Chareau made the legs from
metal supports, which function
both visually and structurally like
a building's I-beams, while
the wooden table top evokes a
building's cantilevered floors.
He created a unified and dynamic
visual vocabulary of materials
and structural elements.
Borrowing cubist techniques,
he emphasized line and implied
volume over mass and the illusion-
istic presence of the object.
Anticipating the ways in which a
person would interact spatially
with the side table over time,
the legs were made to appear
wide and sturdy when approached
from the front, but thin
and unobtrusive in profile. As a
result of this approach, the
negative spaces and potential
views throughout Chareau's
design become as important as
the surfaces that define them.
—M.V.

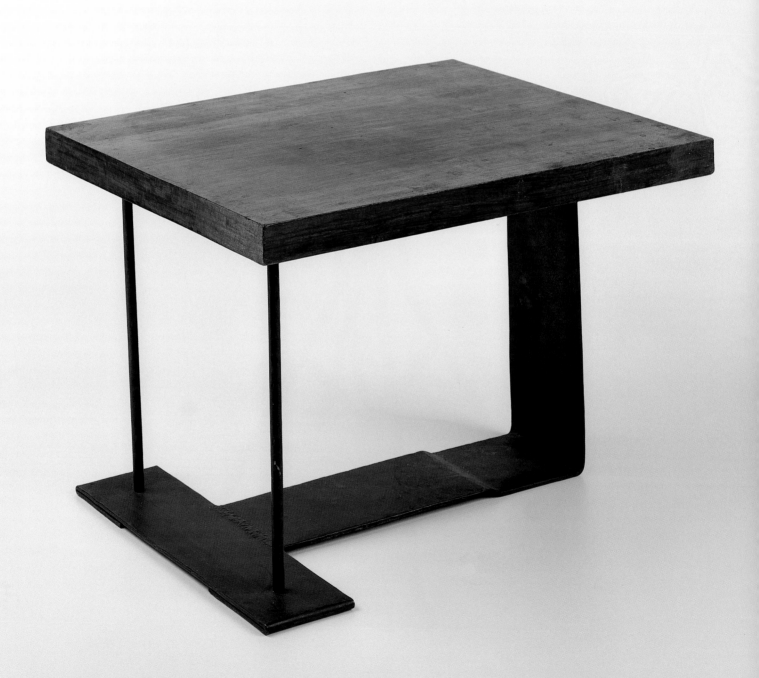

c. **1930**

plate 20

M^cARTHUR

WARREN

TABLE FOR THE ARIZONA
BILTMORE HOTEL,
PHOENIX, ARIZONA

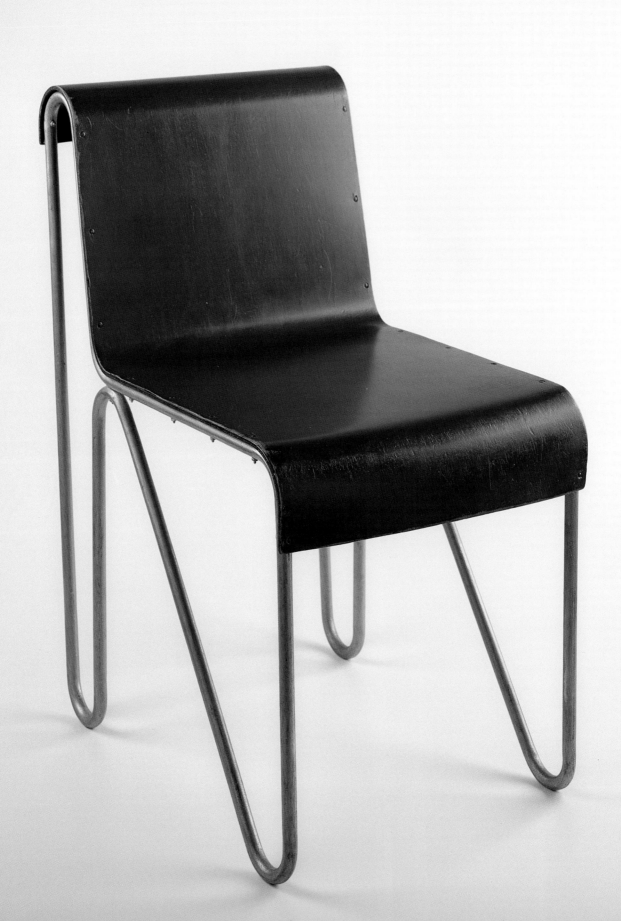

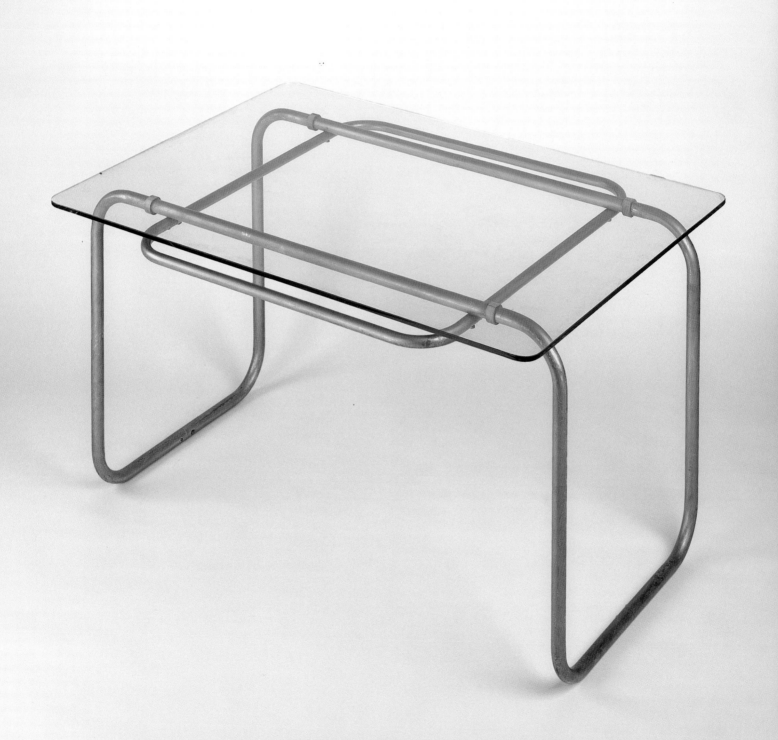

CHAISE LONGUE MODEL LC-4

Le Corbusier referred to his furniture designs (in collaboration with Charlotte Perriand and his cousin Pierre Jeanneret) as "equipment" (*équipement*), not "furnishings" (*ameublement*). He conceived of a dwelling as a "machine for living," and he was bent on eradicating sentimentality from the objects that defined the domestic landscape. The seminal Model LC-4 chaise seems to be a distillation of modernist rational thought applied to the design of functional objects; the machine-like steel base is fixed, while the reclining seat, with its curvilinear outline, is responsive to the needs of the human back—and adjustable. Charlotte Perriand had in mind a soldier at rest under a tree when she conceived of the incline of the movable component.

It is difficult to visualize any of the interiors of Le Corbusier's buildings without his furniture designs, of which this is arguably the most iconic. Aside from his common inclusion of a humble Thonet bentwood armchair, all of the fixtures of his domestic interiors were to be reconceived. Although there was an established tradition for recliners—from the nineteenth-century bentwood examples by Thonet and the Morris Chair to the Freudian analyst's couch—never had there been such a severely reduced version, with all of its structure and operations revealed. The number of versions, reissues, and imitations of this piece, not to mention references to it in works by other top designers, is staggering and perhaps most indicative of its enduring status. Perriand herself believes later editions, like the Italian-based Cassina firm's version, overseen by her since 1964, to be improvements on the 1928 design (better plating, longer-lasting rubber, etc.), but its original context is revealed in this brutally crude early version.

—M.B.

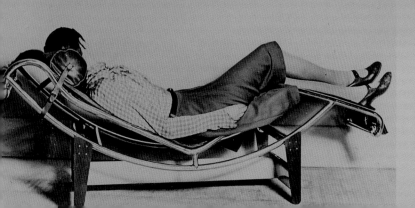

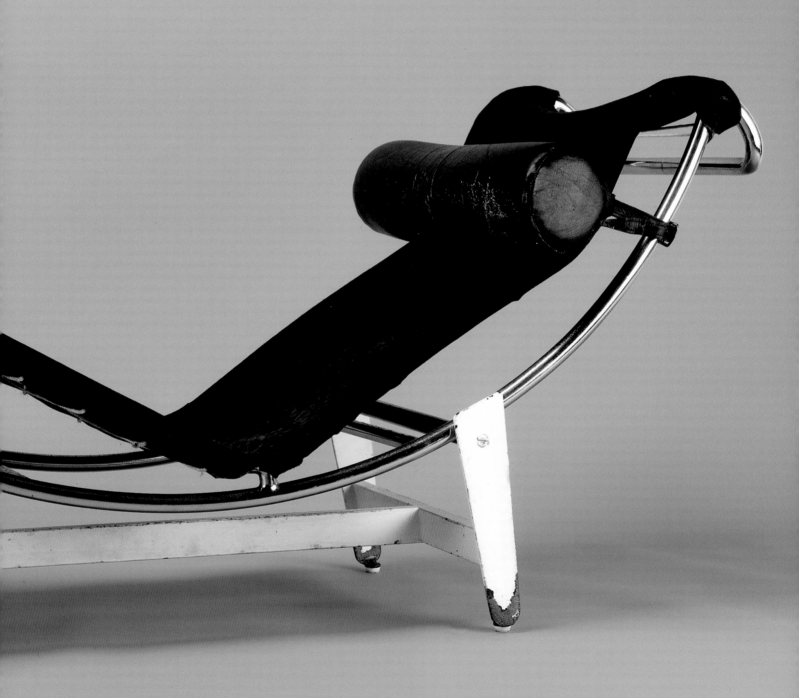

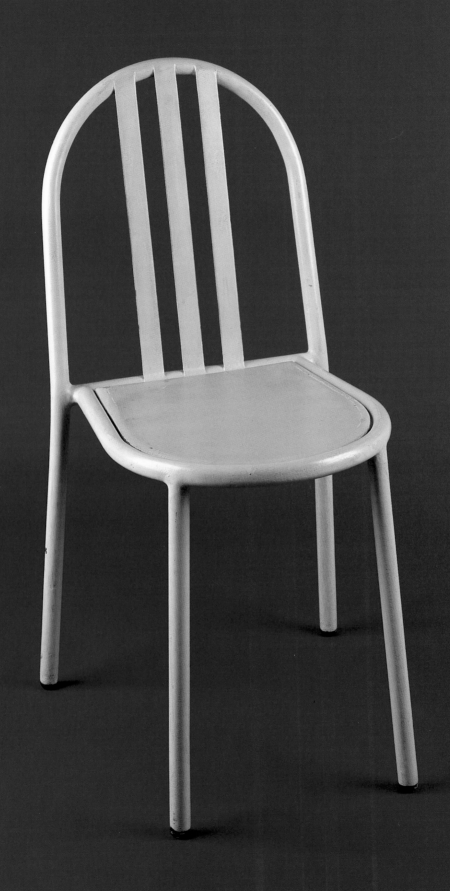

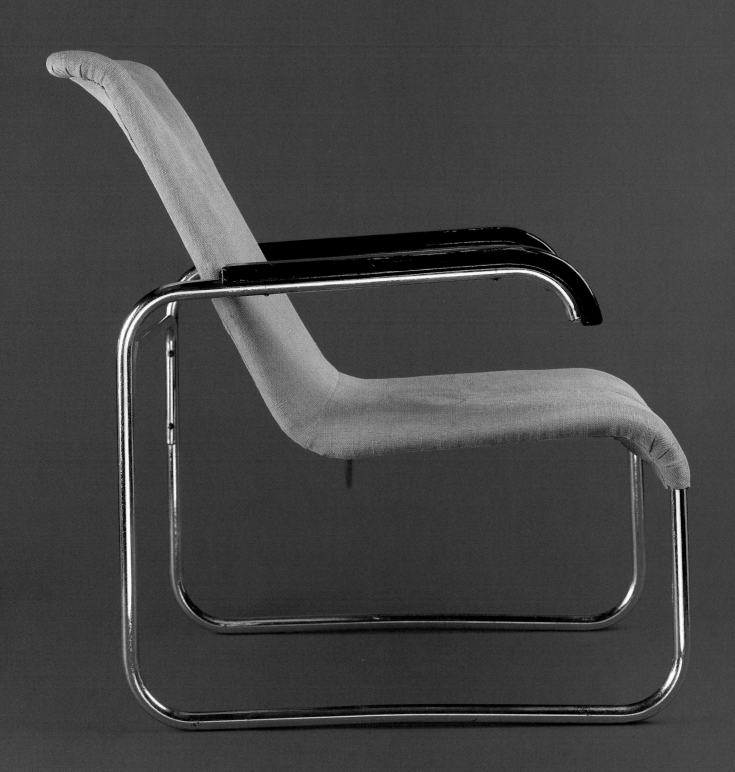

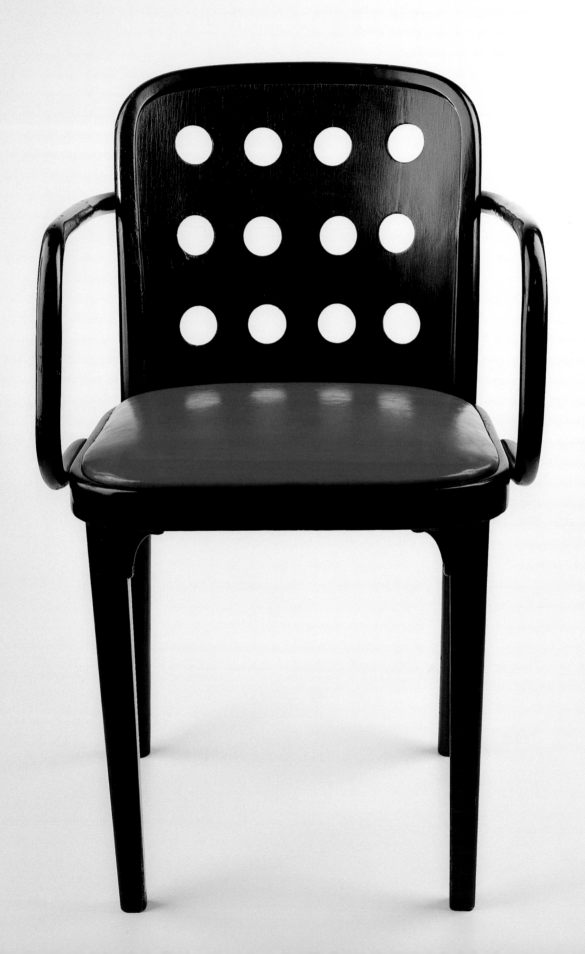

LE CORBUSIER

TABLE FOR THE CITÉ DE REFUGE
DE L'ARMÉE DU SALUT, PARIS

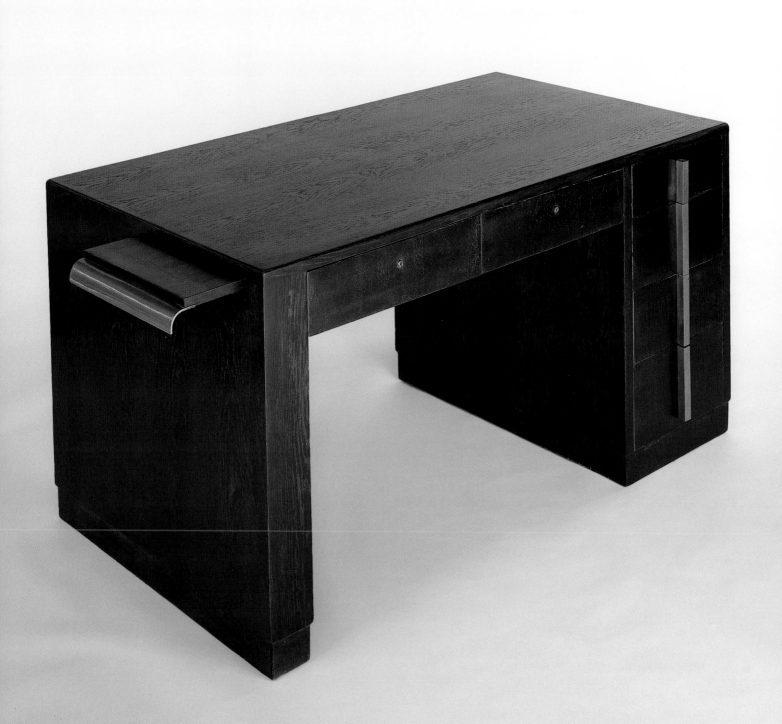

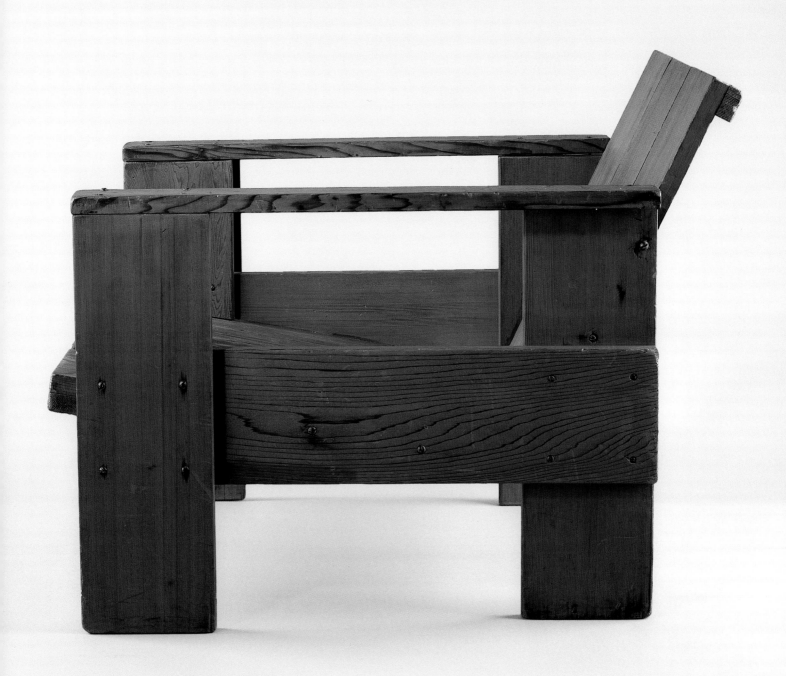

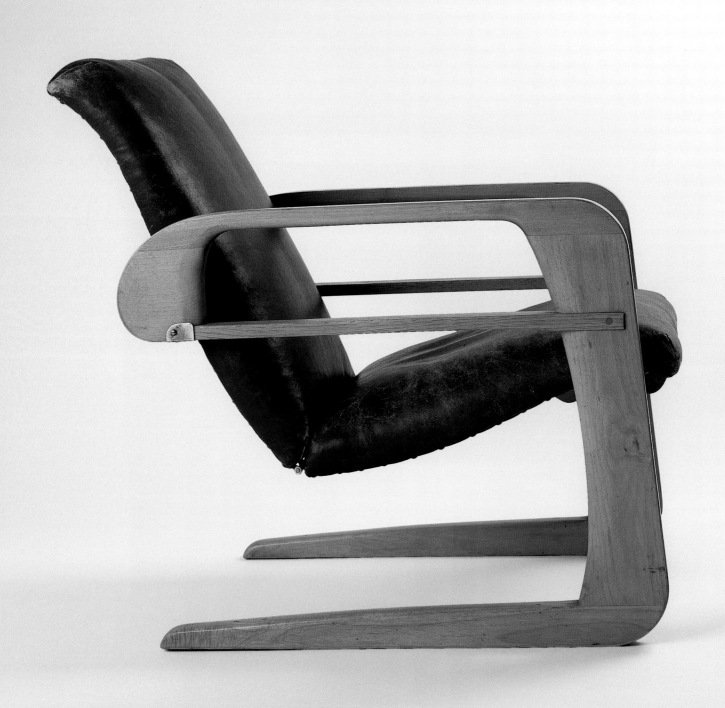

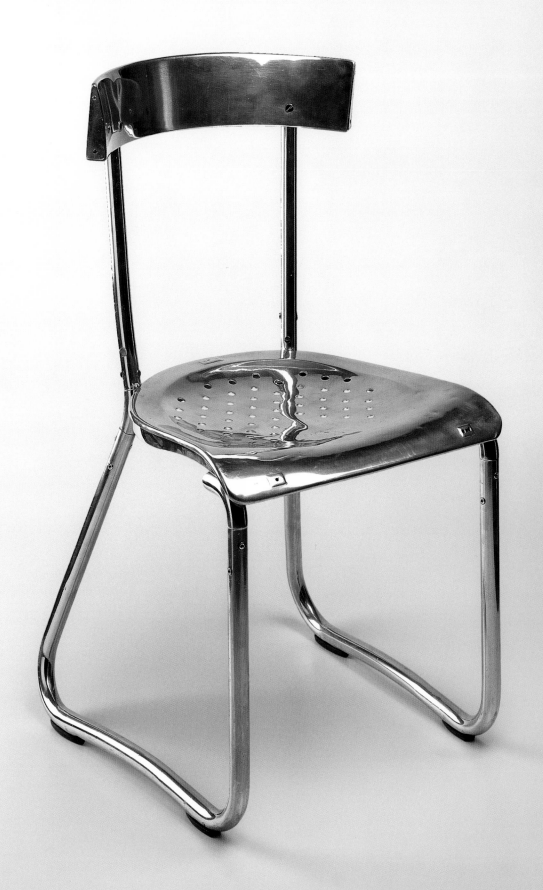

PONTI

GIO

CHAIRS FOR THE
MONTECATINI BUILDING, MILAN

In 1936 Gio Ponti designed both a building and furnishings for the headquarters of the Montecatini Corporation, which was among the foremost producers of aluminum in Italy. At a time when industrial production called for exact and easily repeatable designs, Ponti challenged contemporary notions of standardization. The Montecatini chairs evolved from his practice of creating sequences of unique combinations of individually standardized parts and materials. All of the chairs have in common the use of modern lightweight aluminum alloy punctuated by red vinyl, while each chair provides a variant in function and form. Ponti's designs offered emancipation from rigid notions of design and revealed the possibility of an inherent inventiveness in industrial practices. His versatile and flexible approach, exemplified by the overall harmony of these distinctive yet coherent chairs, was further demonstrated in his ability to, in 1951, seamlessly integrate an additional building into the original corporate headquarters, designed fifteen years earlier.

—M.V.

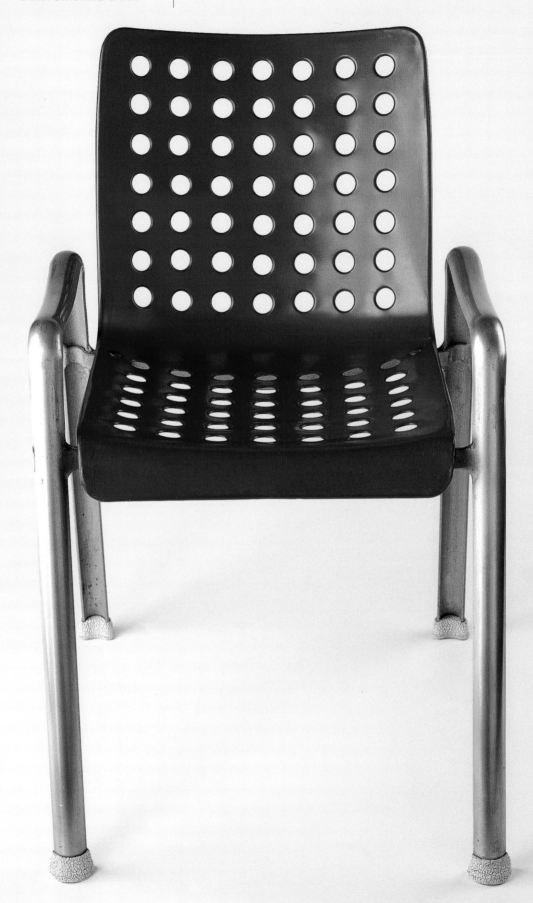

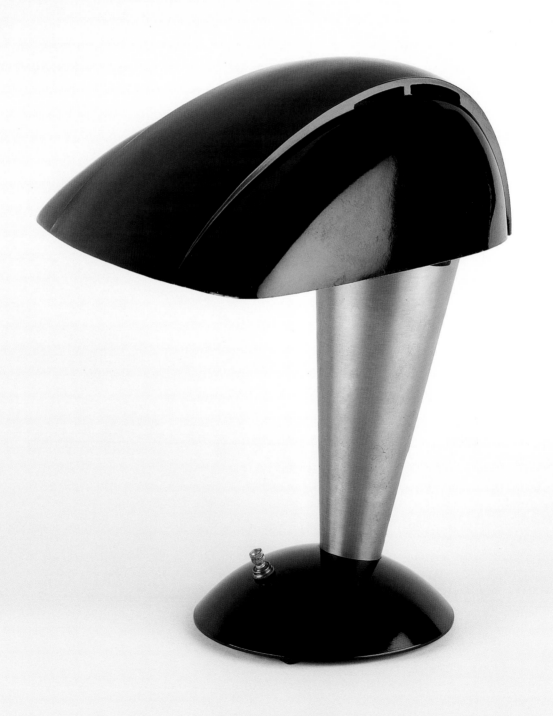

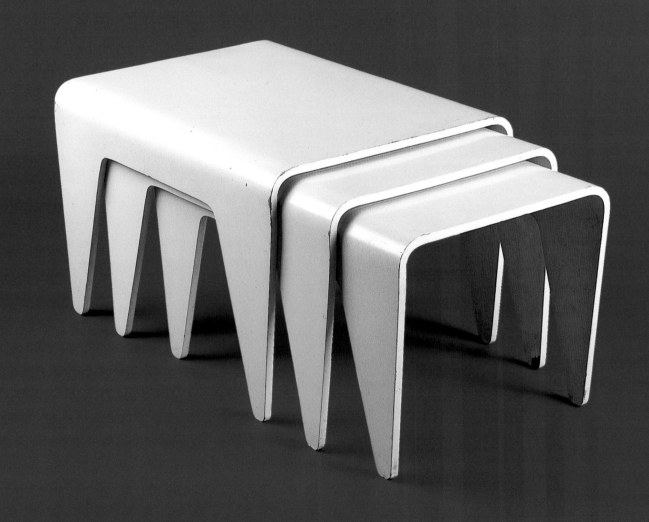

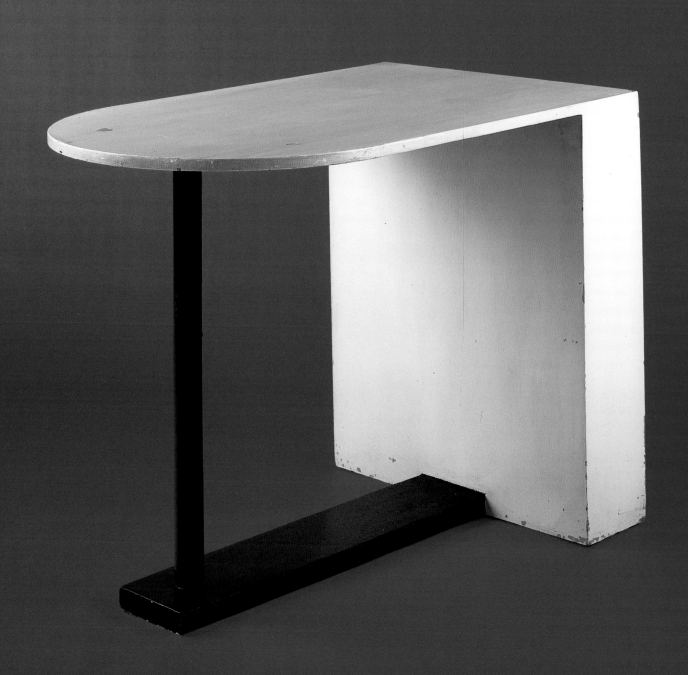

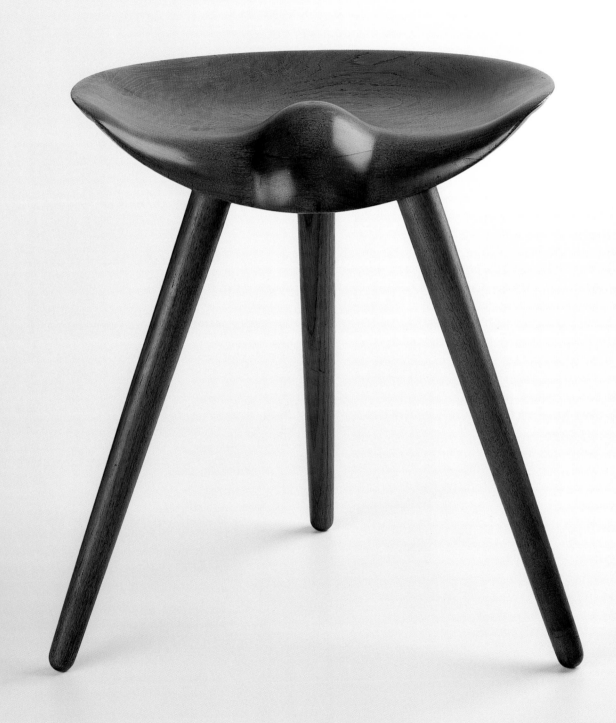

The modern movement reemerged, after the upheavals of the war years, in a variety of new guises. Mies van der Rohe preached a purist vision, but his new paymaster was corporate America, his architecture destined for wealthy patrons. Modernist rationalism was to serve stylistic as well as idealistic ambitions. The industrial infrastructure of the United States had been significantly expanded through the war and was now to generate and serve a period of unprecedented consumerism. The field was wide open for experiment and development in product design.

Architect-designer Charles Eames had experimented during the war with plywood to develop a leg splint for the Evans Products Company. His design was a technical break-through, forming the plywood into multi-directional curves. Eames had unwittingly found a key to a new, organic brand of modernism in which the curve took precedence over the straight line. The Boyd collection enters, in 1945, a phase of increased diversity.

New York's Museum of Modern Art led the way in demonstrating the need for formal sponsorship and promotion of good modern design. The museum set up a department devoted to industrial design in 1940 and staged influential exhibitions, such as the 1941 *Organic Design in Home Furnishings*. In Britain government support was given through an advisory body, the Council of Industrial Design. This was reinforced by the establishment of the Design Council and a permanent gallery for award-winning work, the Design Centre. In Denmark a remarkable private enterprise,

the shop Den Permanente, achieved quasi-official status as the defining showcase of the very best Danish modernist design. In Italy the Milan Triennale exhibitions achieved importance as an opportunity for the comparative display of the best international work, while the *Compasso d'Oro* awards, sponsored by the Rinascente department store in Milan, bestowed the highest prestige on influential bodies and individuals. The Museum of Modern Art and Den Permanente were both to be recipients of this accolade. In Basel, Max Bill, a former Bauhaus pupil, presented in 1949 the first of his *Güte Form* exhibitions. His 1952 book *Form* was a stocktaking of modern movement achievement, its focus very much on the wide dissemination of industrial design ideas first proposed in Germany half a century before. Modern design had now become a truly international language, a transatlantic community of shared ideals.

As the story of modern design up to 1965 unfolds through the Boyd collection, it demonstrates the impact of new aesthetics derived from new technology in large-scale injection-molded plastic objects, as revolutionary in their decade as tubular steel had been forty years earlier. Robert Venturi's 1964 publication *Complexity and Contradiction in Architecture* serves as an apt punctuation mark at the close of the period covered by the collection, a question mark anticipating the challenge to modernist thinking that was to be well illustrated four years later by the disruptive attack by students on the Milan Triennale. An era of clarity, born in revolutionary spirit, was now confronted by new iconoclasts, by a new questioning and subversive generation.

—P.G.

1947

MOLLINO

CARLO

plate 51

**SIDE CHAIR FOR THE
CASA DEL SOLE, CERVINIA, ITALY**

Carlo Mollino's designs were conceived as both vessels and fetishes, meant to support the human body in its various activities while also evoking objects of desire. Mollino used the human figure as model, anthropomorphizing inanimate materials such as wood and metal to allude to the female body as the archetypal form. The Casa del Sole chair's most explicit female reference is in the subtly curved yet upright posture of its slender, split back. Structurally, Mollino's way of connecting the back directly to the legs of the chair mimics the gesture of outstretched arms supporting the trunk's weight as it leans backward. The chair's intimate scale and form suggest a certain anatomical specificity. These motives and themes prevail throughout the great variety of Mollino's designs, which range from aircraft, automobiles, and skiing paraphernalia to buildings, theater sets, and fashion design.

—M.V.

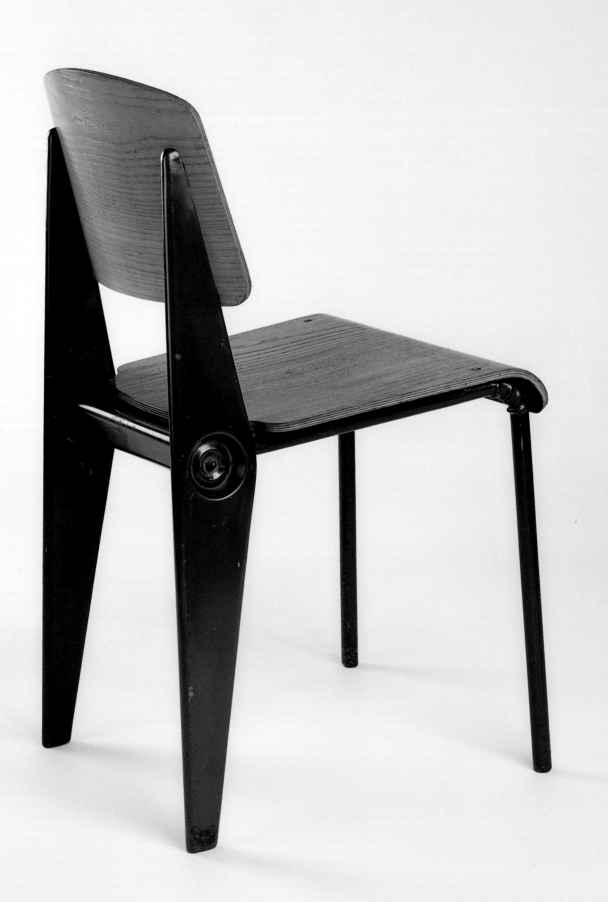

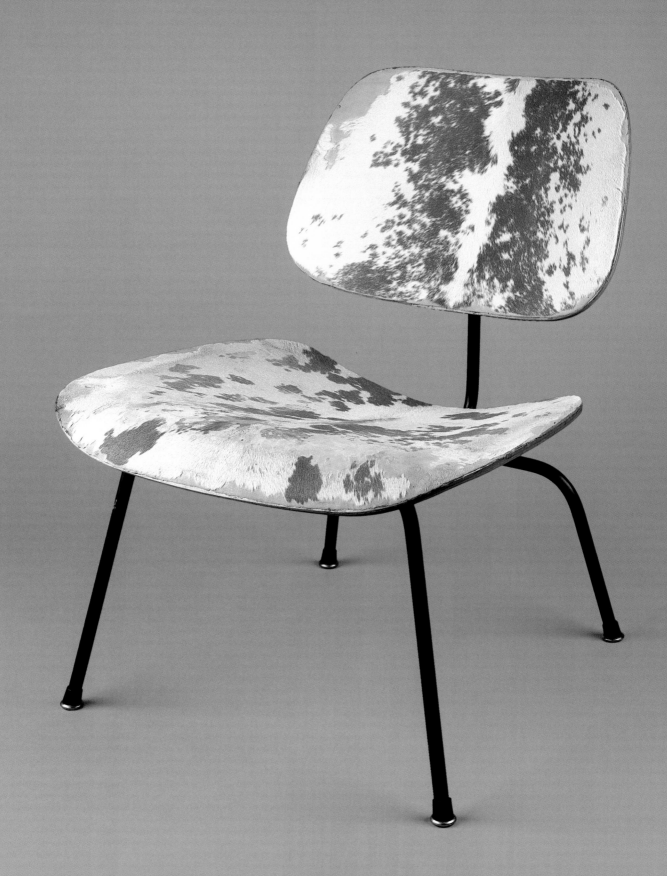

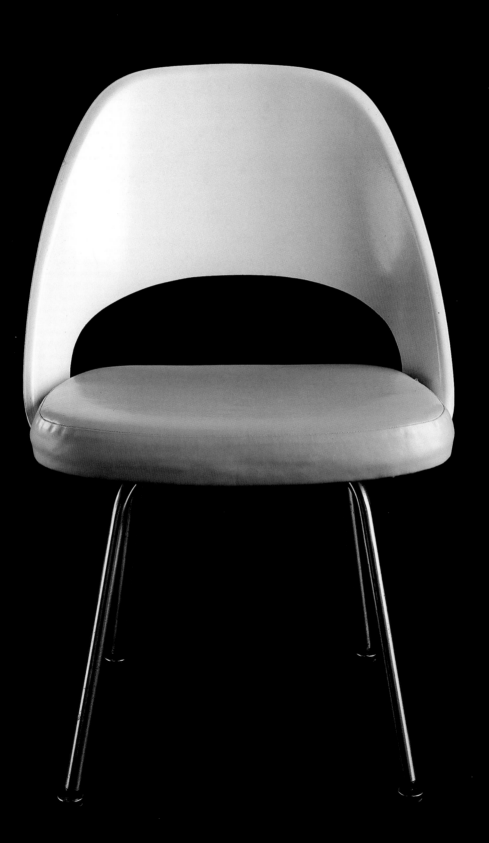

1948

plate 57

SCHINDLER

RUDOLPH

CHAIR FOR THE
LECHNER HOUSE, LOS ANGELES

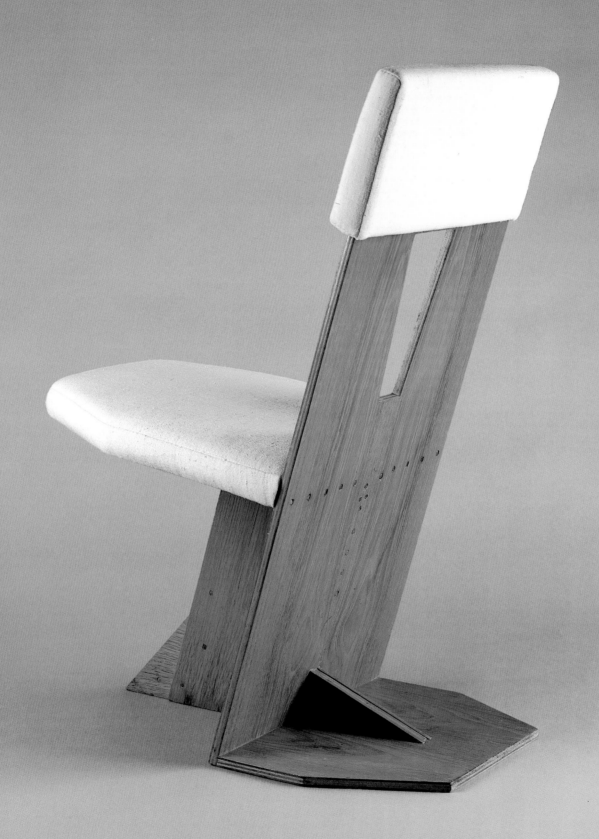

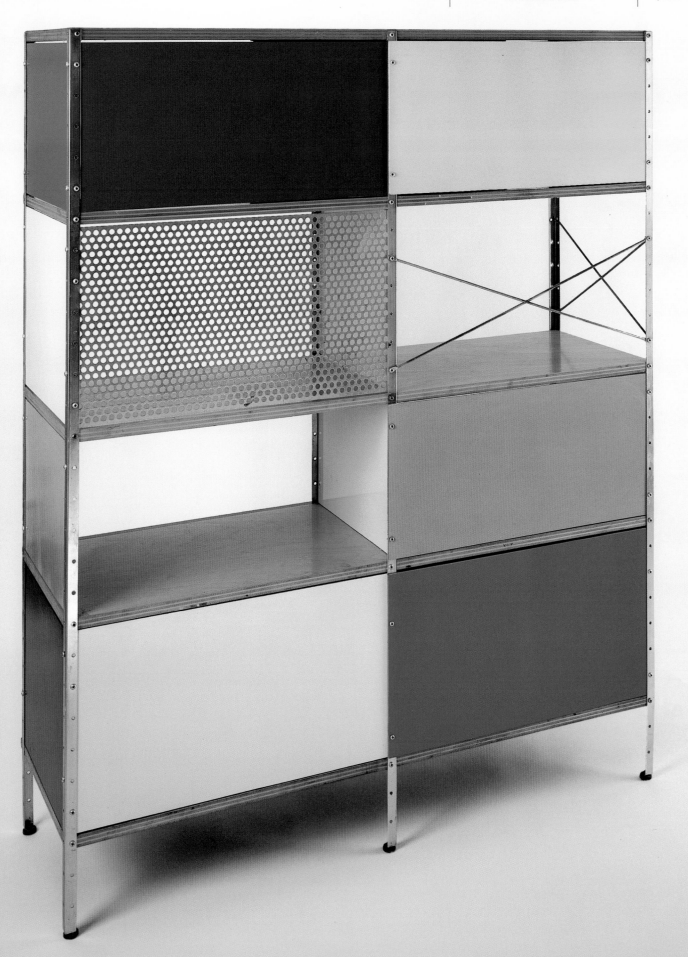

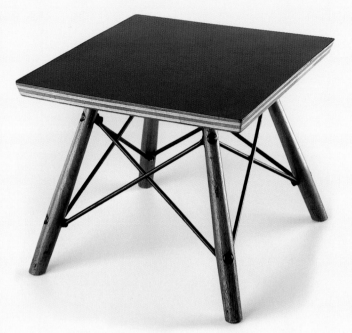

CHARLES & RAY **EAMES** c. **1950**s

PROTOTYPE FOR THE
DOWEL-LEGGED SIDE TABLE plate 66

CHARLES & RAY **EAMES** **1951**

DKW-2 CHAIR plate 67

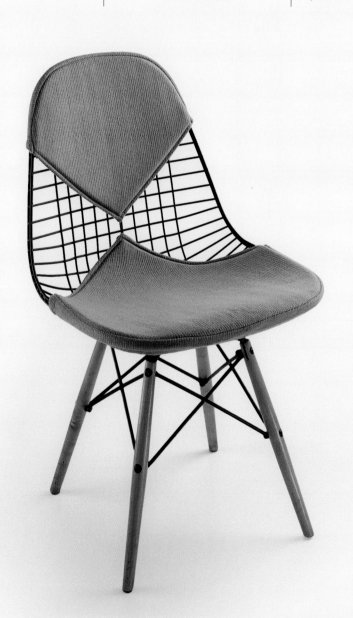

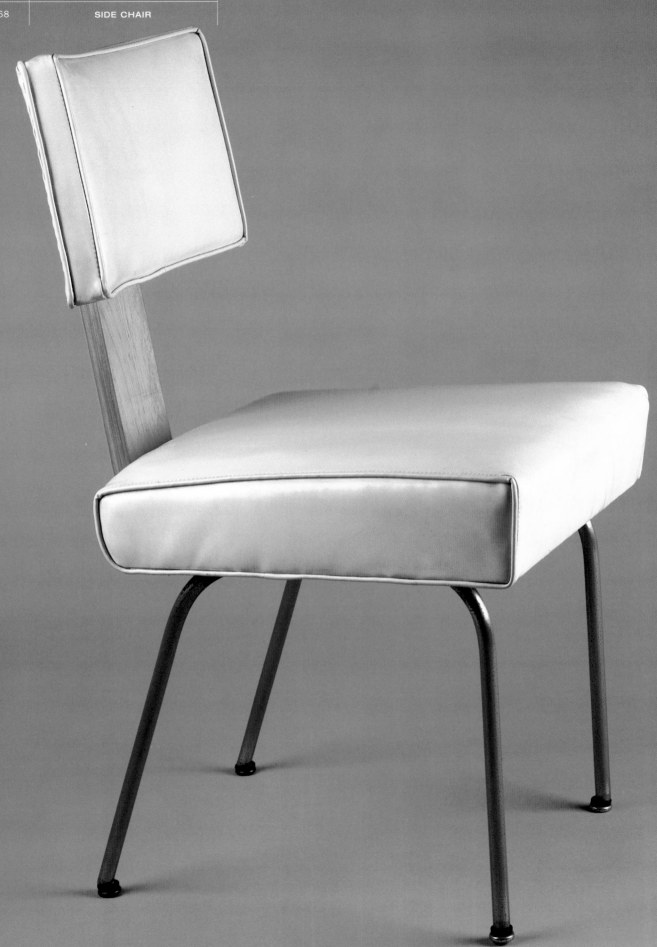

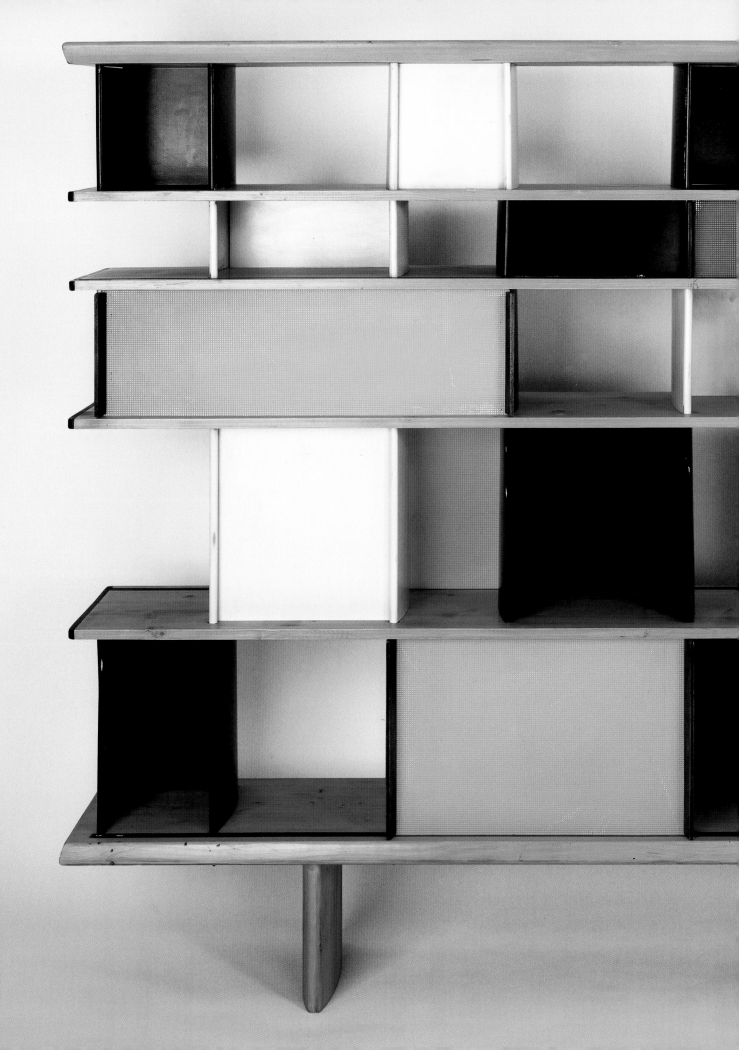

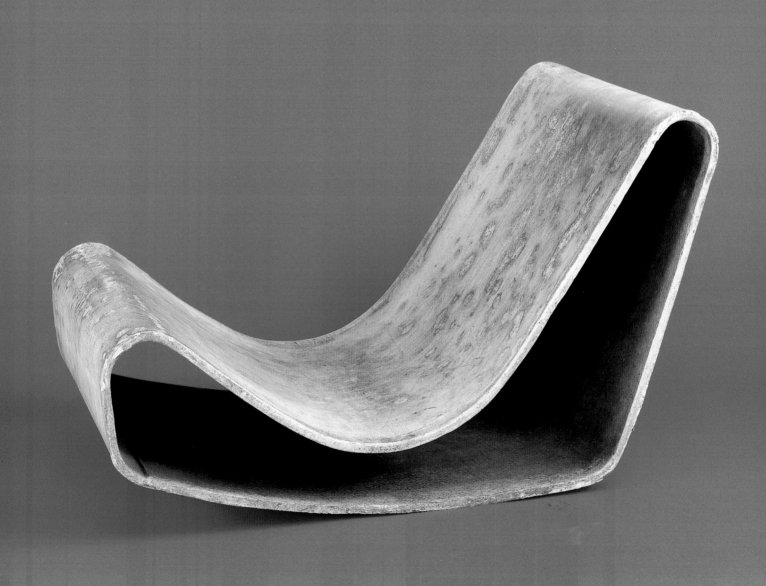

1954

plate 75

MOLLINO

CARLO

**TABLE FOR THE
PAVIA RESTAURANT,
CERVINIA, ITALY**

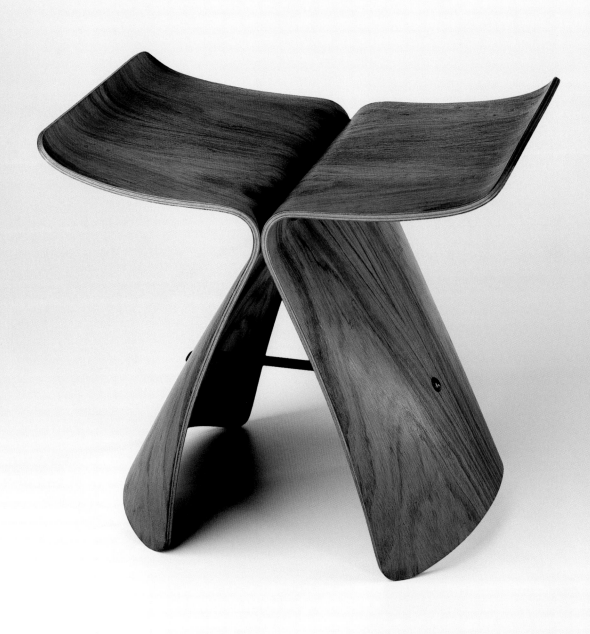

Impractical from its conception through its production, George Nelson Associates' Marshmallow Sofa has derived its staying power purely from its formal, visual qualities. The striking atomic image has overshadowed the reality of its use; those who attempted to sit on the outermost cushions often ended up on the floor with the sofa on top of them. In the same Herman Miller series as the Coconut Chair of 1955, the Marshmallow Sofa recalls Nelson's own Ball Clock of 1949 for Howard Miller (pl. 61), in that in its finished state it appears to be an "exploded" view, like a blueprint revealing structure or a diagram-model. The floating effect of the matrix created by the circular cushions above the minimized leg system was pursued by the Nelson office (and other top designers) during the post–World War II era;

the heaviness of traditional club chairs and couches was to be avoided at all costs. The painted steel and aluminum components that make up the infrastructure appear skeletal, while the eighteen cushion units combine to create a conventional "upholstered slab," which hovers above. Irving Harper, in charge of developing the "Marshmallow" at the Nelson office, went through several stages before arriving at a final design; all of the changes were dictated by the requirements of mass production. Originally, square stock steel beams were conceived for the frame, but tubular steel ultimately offered a more structurally sound foundation and was easier to fabricate. The initial design also featured a multirod connection where the cushions met the frame, but the handwork required proved too costly. Even with streamlined production costs and refinements

in the design, the sofa was not a success and soon went out of production. An exercise in optics, the Marshmallow Sofa in a sense anticipated the benday dots introduced to the fine art world by Roy Lichtenstein when he appropriated newsprint cartoon imagery for his paintings in the early 1960s. It can also be seen as a negative image of the perforations widely used by modernist designers—from Otto Wagner (1904) and Josef Hoffmann (1929) through Hans Coray (1938) and Charles Eames (1950). Recently reassigned from the realm of kitsch to that of high design, the Marshmallow Sofa is emblematic of the buoyant, overly optimistic atmosphere of the postwar design world.

—M.B.

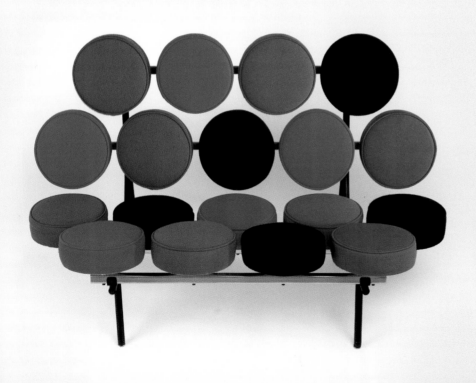

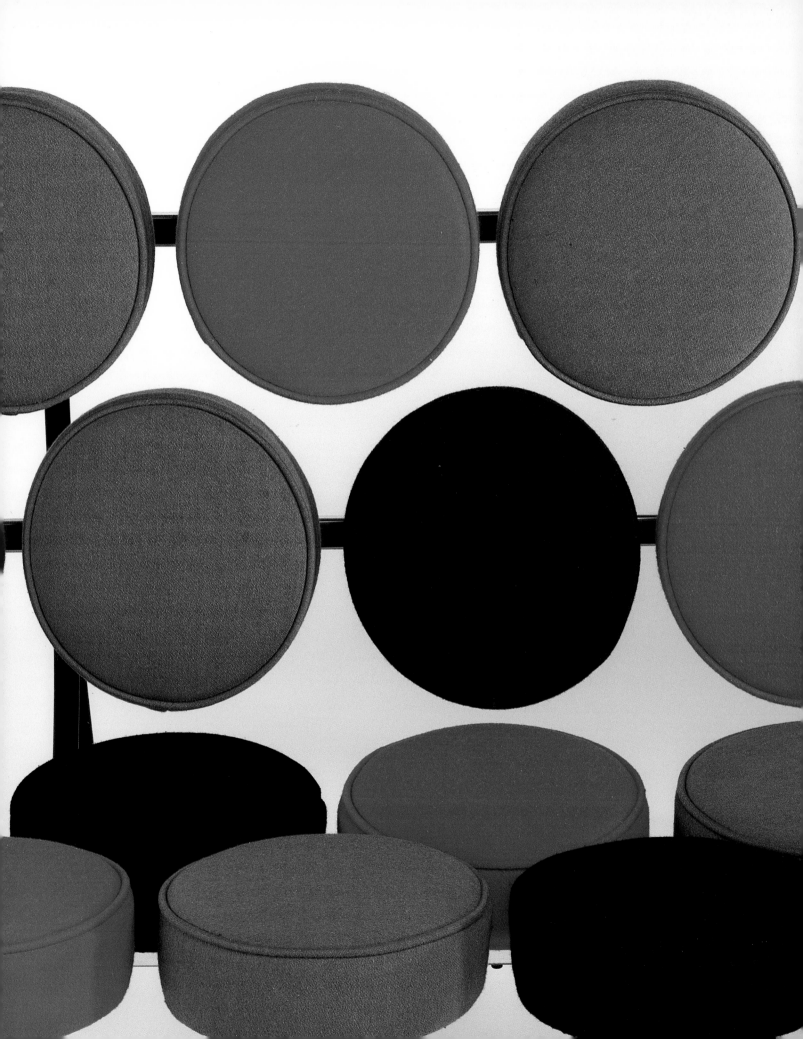

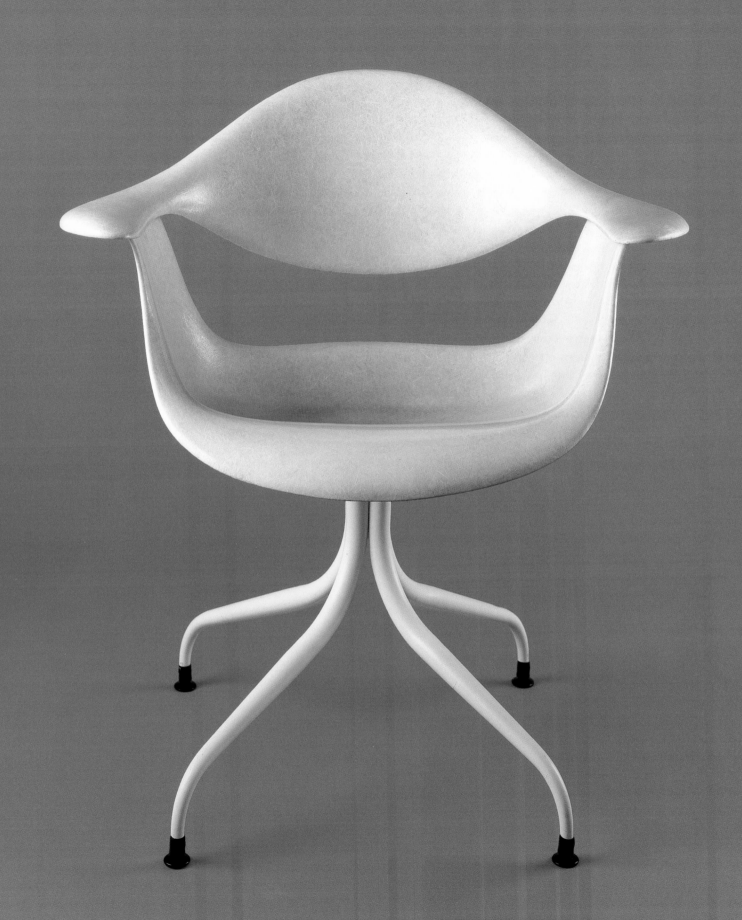

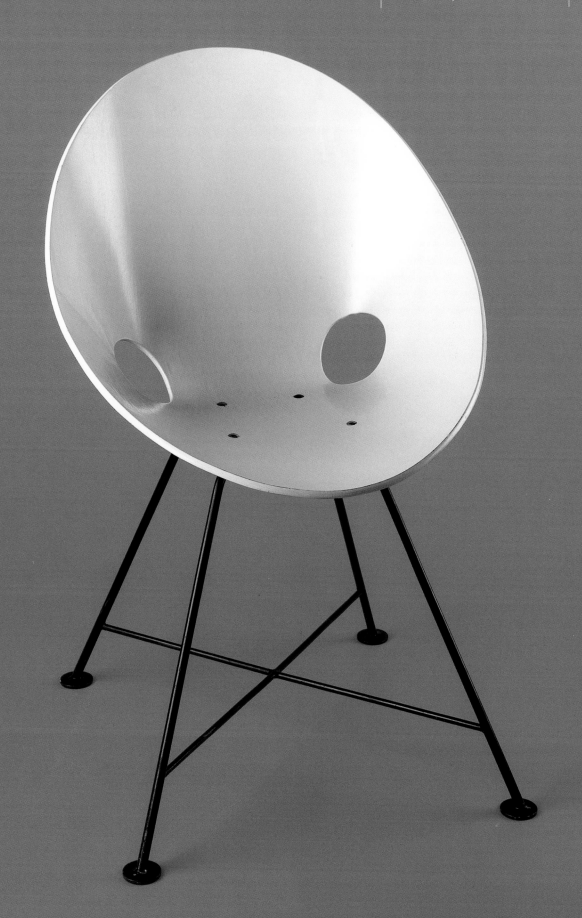

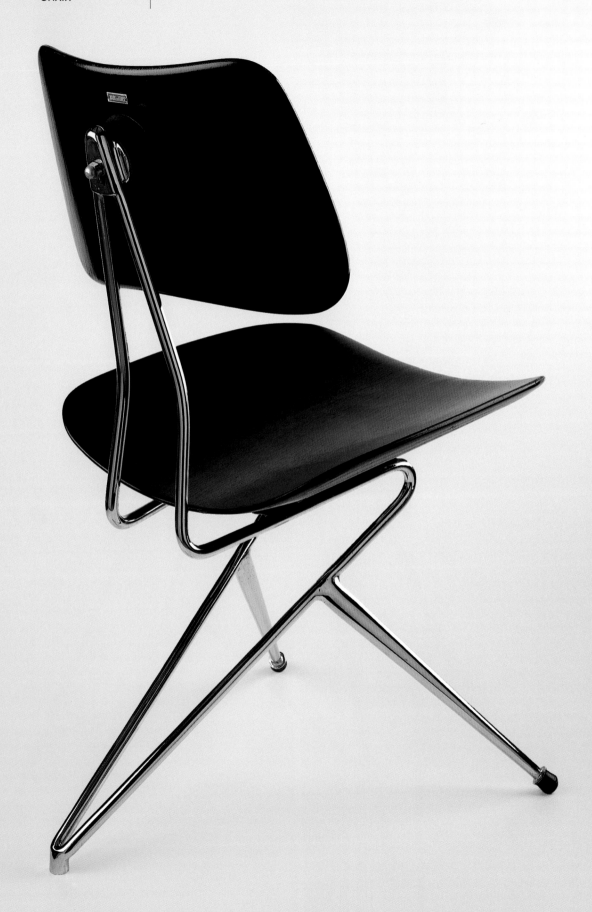

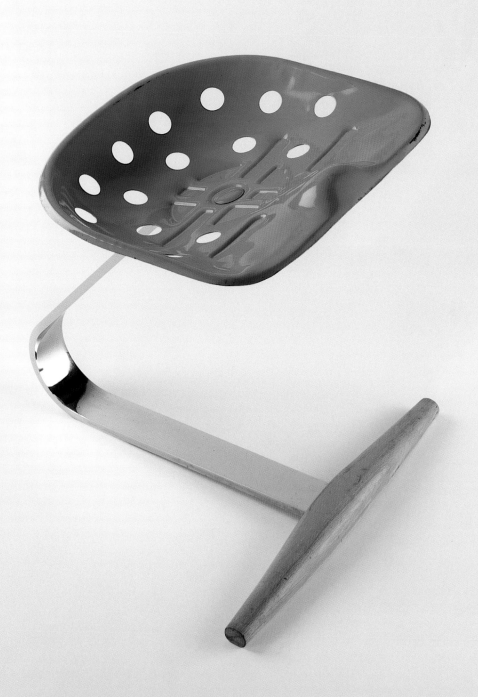

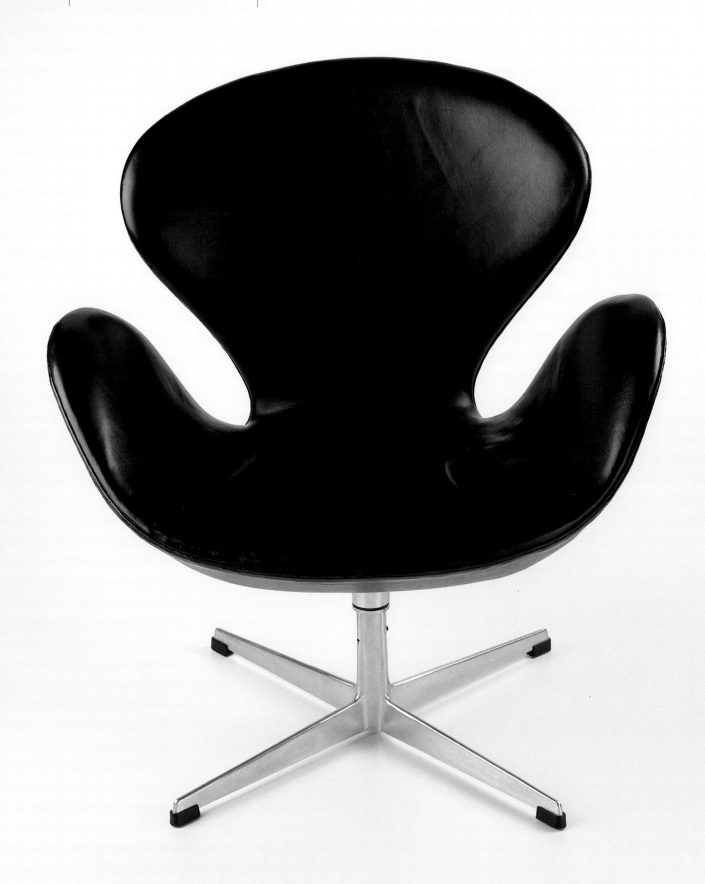

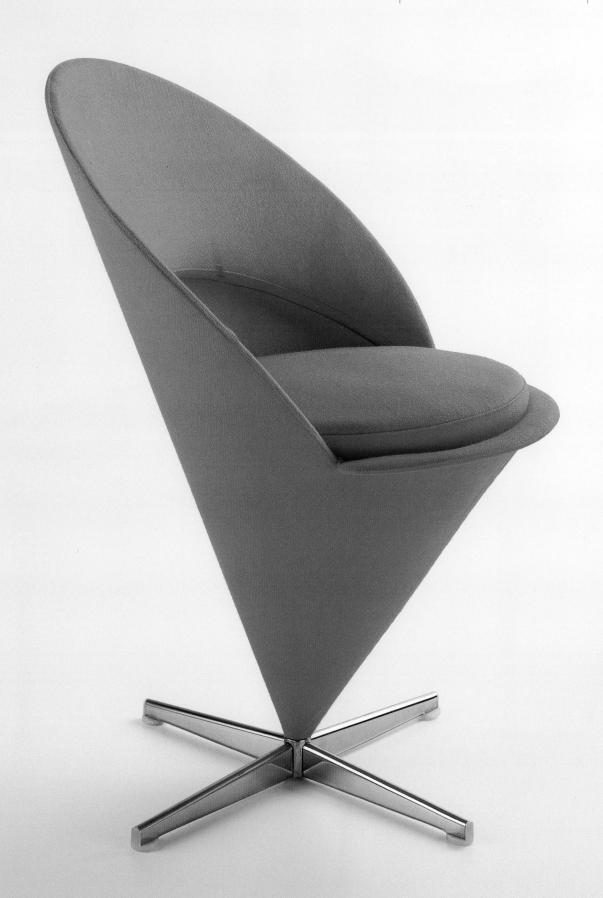

1958

plate 91

JOHNSON

DAN

**DINING CHAIR FROM THE
GAZELLE LINE**

This chair was conceived by Arne Jacobsen for the refectory of Saint Catherine's College in Oxford, England, for which he was also the architect. Jacobsen designed this uniquely proportioned chair for the fellow's table, to set the honored fellows apart, both physically and visually, from the surrounding students in the dining hall. Its form takes an innovative approach to the age-old role of furniture in dictating how individuals behave and are perceived by others. From the back, as the chair would normally be seen, it appears severe, monumentally upright, and imposingly massive. When seen in profile, the focus is shifted to the sitter, and the chair dissolves into a subtly curved outline. The almost invisible supporting structure of the legs enhances this symbolic transformation. The social reading of the chair relies on the observer's ability to transfer status from chair to sitter. The chair's ultimate aesthetic success lies in the fact that it transcends its original historical context, achieving an elegant balance between contour and mass.

—M.V.

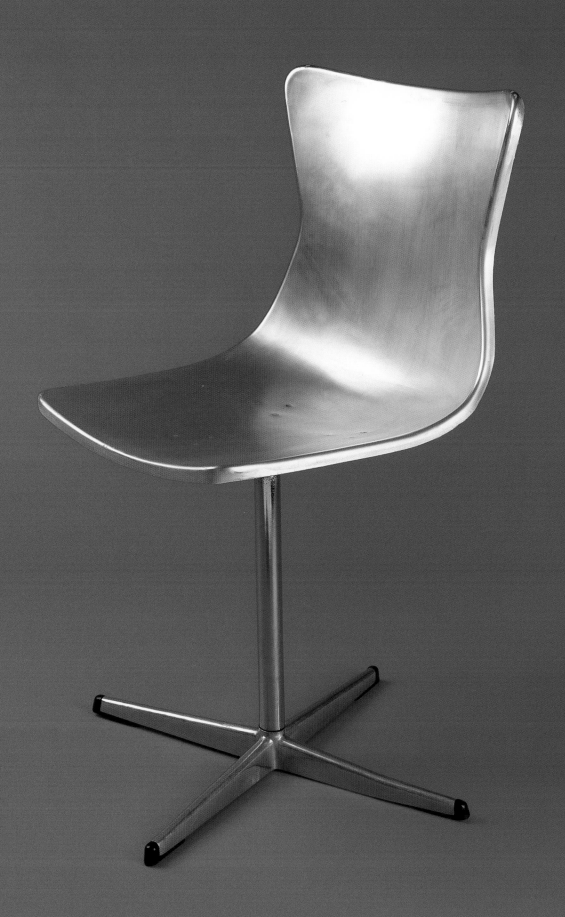

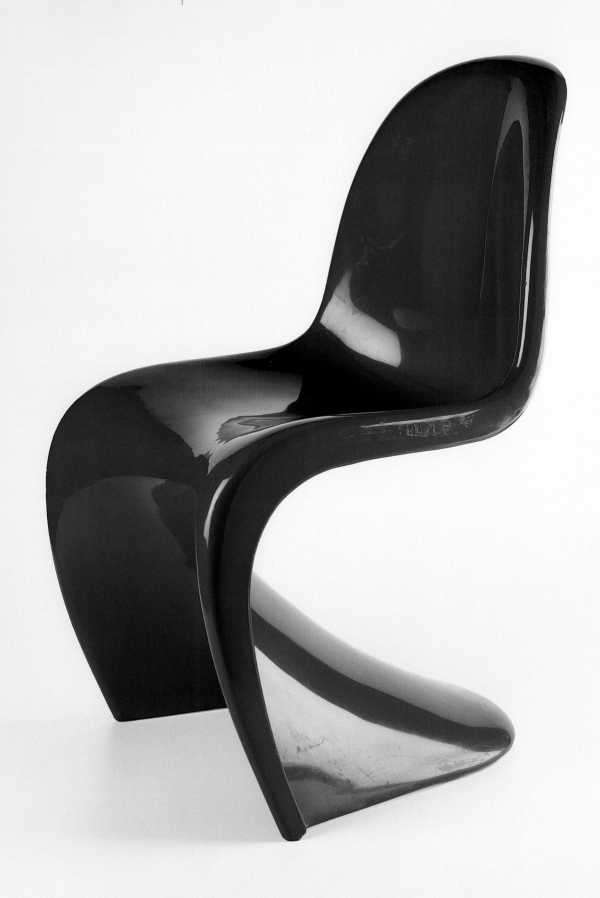

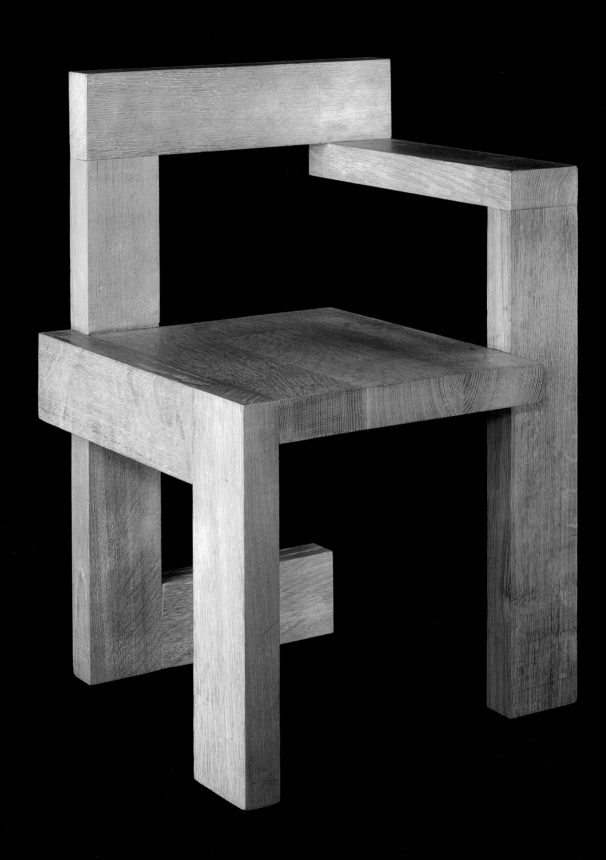

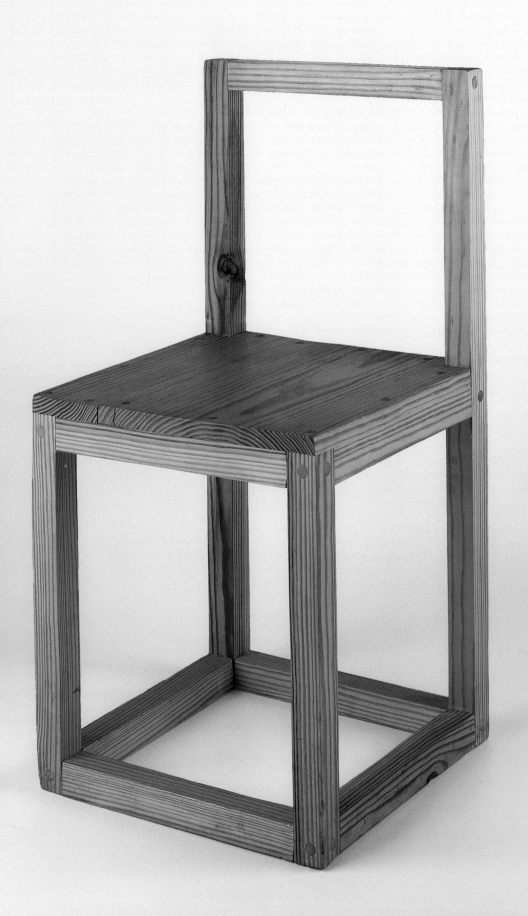

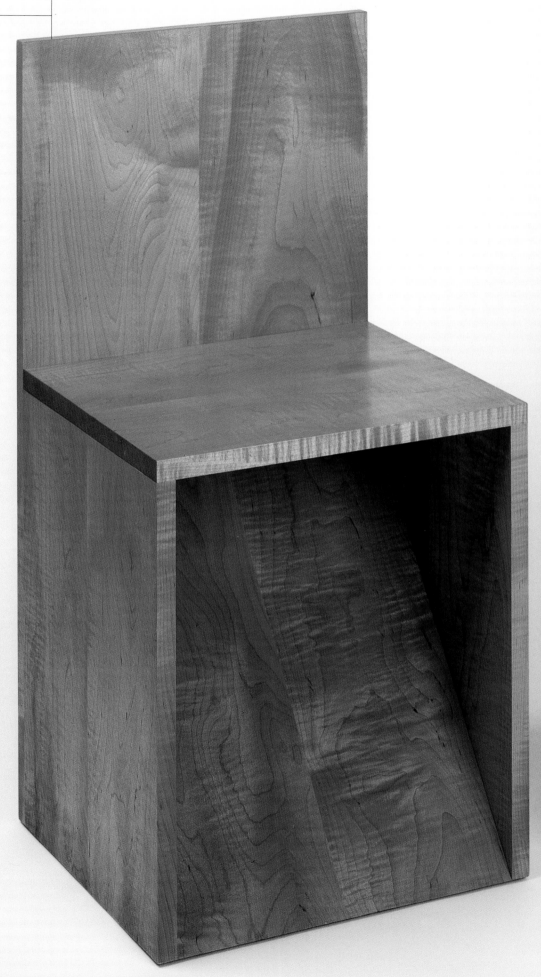

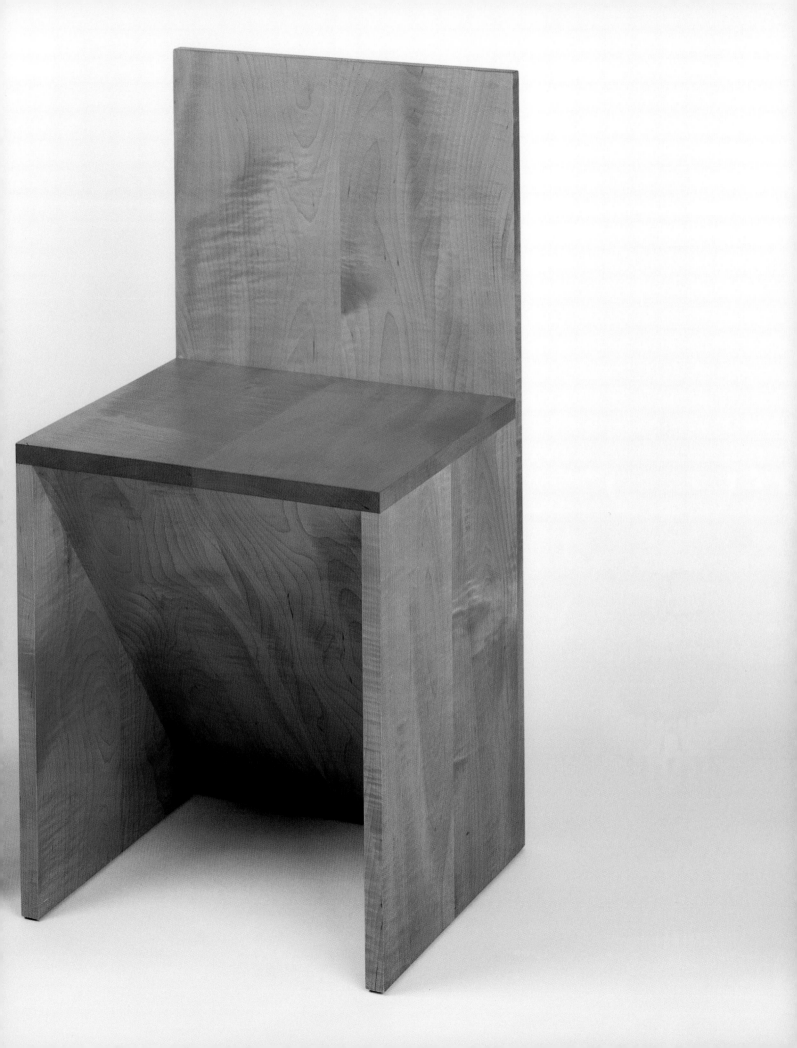

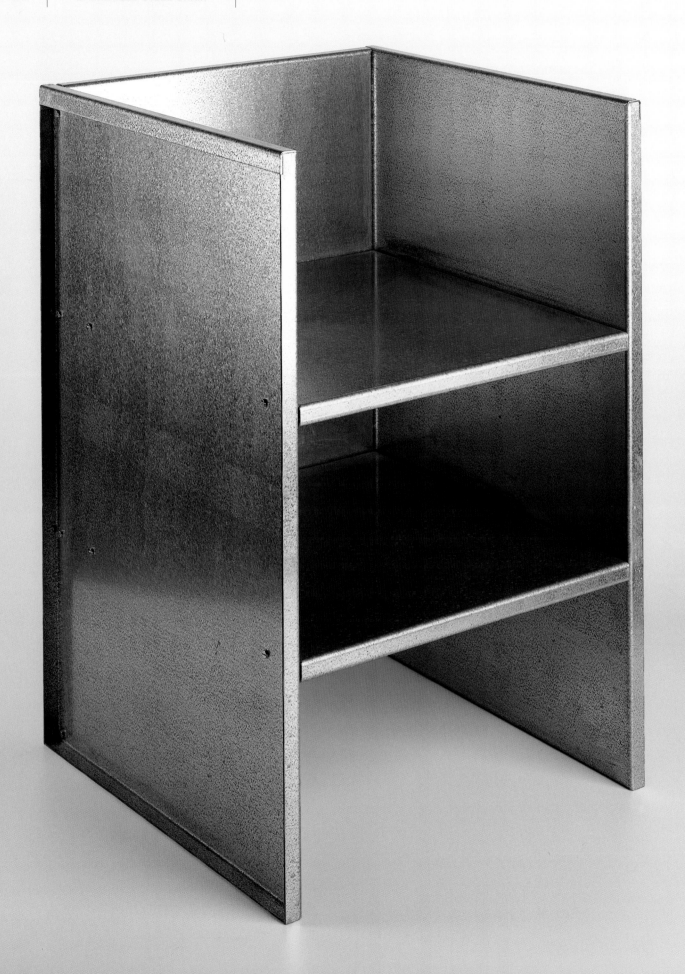

CONSTRUCTED PAINTING

ONE CAN FIND SOME OF PAINTING'S MEANINGS BY LOOKING
NOT ONLY AT WHAT PAINTERS DO BUT AT WHAT THEY REFUSE TO DO.

AD REINHARDT

The pictorial "problems" of symmetry/nonsymmetry, composition/noncomposition, foreground/background, and so on, come up as a matter of course for abstract painters. Over the years artists have come up with vastly different "solutions," but those included in *Sitting on the Edge* share a focus: Josef Albers, Burgoyne Diller, Donald Judd, John McLaughlin, and Myron Stout have in common a resolute move away from "expressionism"—away from autobiographical specifics and eccentricities—away from the handmade record. The works included in the exhibition are all reductive, constructed works that shun any type of spatial illusionism, all forms of depiction and traces of subject matter.

Albers, Diller, Judd, McLaughlin, and Stout have been associated with movements such as constructivism, minimalism, hard edge, geometric abstraction, and neoplasticism, but they were all "construction-ists" in the sense that they executed meticulous maquettes, models, and working drawings and adhered to them strictly. By contrast, the old-world easel or landscape painter may have made a preliminary sketch for the general organization of the canvas, but all subsequent work was an effort to put the artist's autobiographical thumbprint *into the painting*. The *Sitting on the Edge* artists hoped to create something as flat and anonymous as the mockup. It's as if the artist were trying to paint himself—the imprint of his own hand—*out of the work*. Above all else, the artists pursue radical reduction—the eradication of the nonessential and the seeking out of a "zero-balance" of silence and purity.

In addition to the philosophical sympathies of these artists, there is a visually obvious connection among their works: architectonics. The great pioneers of rectilinear abstraction, Kazimir Malevich and Piet Mondrian, employed the rectangle and other architectural forms as a default tool, one that enabled them to avoid subject matter per se and any sort of representation of the natural world. In essence, it was a tool to achieve *total* abstraction—one that could bring about neutrality and even, in its most idealistic phase, transcendence. In *Painting toward Architecture* (1948) Henry-Russell Hitchcock explored the close relationship of modern painting and architecture, particularly the work of Mondrian and the other De Stijl artists and International Style functionalism. Mondrian's and Theo van Doesburg's grid systems, as well as the use of planar elements in their works, strongly influenced the architectural language of functionalist modernism. In Mondrian's Paris, London, and (especially) New York ateliers, as well as in van Doesburg's Meudon studio, it was not entirely clear where the architecture ended and the paintings began. Planes of color on the wall became architectural components, and the interlocking rectangles of the architecture flowed directly into the artworks.

The connection of the artists represented in *Sitting on the Edge* to architectural design is not so straightforward, but the strong sense of structure (underlying or overt) and architectonic spatial organization in these works relates them to architecture.

Hitchcock noted that, as early as 1917, the more radical De Stijl members were referring to the "swindle of lyricism and senti-mentality."[1] The artists in *Sitting on the Edge* came to a similar (although independent) conclusion: the architectonic/planar approach allowed the artist to circumvent particularities in favor of a universal and timeless language.

The idealism and poetics of the early twentieth-century abstractionists did not endure. The utopian dream of a universal art creating a new world did not survive the social and political upheavals of the 1930s. Geometric, abstract art gave way to social realism. Constructivist art became an intellectual exercise, losing its original spiritual under-pinnings. The quest for universal harmony is not necessarily embodied in all of the artworks in *Sitting on the Edge*, but certainly these works have roots that can be traced back to the seminal early twentieth-century work of the Dutch and Russian constructivists.

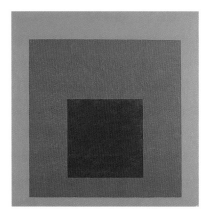

Josef Albers's achievement as a painter was perhaps overshadowed by his reputation as a teacher, lecturer, and writer. The first of the transplanted Bauhaus masters to come to America, Albers was an extremely prolific artist. The last twenty-five years of his production consisted almost exclusively of a series of radically reduced geometric works: his epic Homage to the Square exercises. *Homage to the Square, Green Tension* (1951; pl. 101) was executed two years after he began the studies that examined, as he put it, "the discrepancy between physical fact and psychic effect" through the relativity of color (the idea that a color could be transformed by its context or proximity to another color). Although Albers was preoccupied with the mechanics of vision and the performance of color and light, he achieved a high degree of emotional, not just optical, impact. The frontal and symmetrical square-within-a-square composition at which he arrived broke away from the relational or asymmetrical composition of Mondrian and anticipated the unity of 1960s minimalism.

Burgoyne Diller, along with Ilya Bolotowsky, was a founding member of the American Abstract Artists group and has been generally recognized as the first American disciple of Mondrian. As early as 1934, Diller employed rectilinear grids and primary color planes—the neoplastic vocabulary pioneered by the great Dutch artist. Like Albers, he is perhaps best remembered for his non-art-making enterprises. As the head of the mural division of the New York City section of the Federal Art Project (WPA), Diller tirelessly advanced the work of others (including Bolotowsky, Stuart Davis, Willem de Kooning, Ad Reinhardt, and David Smith). Ultimately Diller felt compelled to move (at least incrementally)

away from the somewhat exhausted possibilities of primary colors and right angles. The decision in his breakthrough mature work to establish a nihilist black background, as in his First Theme paintings (1959–64; cat. nos. 28–30, pl. 102), came after decades of first-rate explorations within the Mondrian idiom. His return to nonrelational composition in the late 1950s and early 1960s flowed into 1960s minimalism, yet he never severed his connection to the pivotal early twentieth-century work of the constructivists.

Plate 101
Josef Albers
Homage to the Square, Green Tension,
1951

Plate 102
Burgoyne Diller
First Theme, 1959–60

Donald Judd, not really a painter since his early days (but, in his own terms, a builder of "specific objects"), distrusted spatial illusionism and sought a more factual form of expression, away from the ambiguities of subject depiction and metaphorical references. He began his career as a critic for *Arts* magazine in New York City, where he immersed himself in the goings-on of the resident avant-garde. In fact, like Diller, he was an early champion of other artists—John Chamberlain, Dan Flavin, Yayoi Kusama, and Frank Stella, among others—and remained loyal and dedicated to their work throughout his life. His early works consisted of objects embedded in the faces of monochromatic canvases; there was no illusion or depiction whatsoever. He pioneered the use of industrial materials and reluctantly became a founding father of minimalism (a label he never cared for). Echoing Stella's credo "what you see is what you see," Judd's output focused strictly on materiality; the totality of the work was limited to its formal properties. The untitled sculpture of 1987 (pl. 103) is from his Swiss Box series, which brought together the use of industrial materials with the color tension experiments of Albers. Most examples in the

series feature more subtle contrasts of color; the unusual red/yellow/blue palette alludes to the neoplastic color scheme of Mondrian and is perhaps an homage. Judd was also quite active in architecture and design. His pragmatic approach produced elegant results in architecture projects in Switzerland, New York, and Marfa, Texas. His furniture designs (pls. 98–100) breathed new life into a constructivist vocabulary dormant since the late 1920s work of Gerrit Rietveld and Marcel Breuer.

John McLaughlin took a pronounced Eastern approach to Western abstract painting. He cited as his tool the use of "neutral forms" and applied them with control and austerity. He borrowed from sixteenth- and seventeenth-century Japanese calligraphers and printmakers the technique of surrounding a minimal gesture with large amounts of open, unused space. He also cited as an enormous influence the transcendental abstractions of Malevich, specifically *White on White*. He saw a parallel between the three-hundred-year-old Asian work and the

Russian Malevich's suprematism; they both touched on the idea that the true essence of nature was a creation of human consciousness, not something from the outside world. It existed in the landscape of the mind and was a source of pure contemplation. McLaughlin contended that in most Western painting there existed an authoritative, declarative voice that suffocated the viewer's possibilities for self-discovery. Through the construction of objects of contemplation—paintings created out of "neutral forms"— he freed the viewer to look inward. McLaughlin worked in relative isolation at Dana Point, in Southern California, and did not begin painting full-time until he was forty-eight. Working independently (although he was often lumped together with other "hard-edge" California painters like Karl Benjamin and Lorser Feitelson), he developed a silent and neutral art that eliminated any reference to a subject, but at the same time he was not overly polemical about his paintings being objects.

151

Plate 103
Donald Judd
Untitled (Swiss Box), 1987

Plate 104
John McLaughlin
Untitled, 1957

The sole representative in the exhibition of the curvilinear organic impulse in painting is Myron Stout. In his case, the sense of calm that comes with order is misleading. He worked in an obsessive manner that he himself considered exasperating. *Heirophant* (fig. 105) was created over an extremely long stretch of time, 1955 to 1979. He would constantly shift and reshift, paint and repaint the outline of the emblematic, hovering form. He was perpetually perfecting, building up, and redefining the "ideal" image. *Heirophant* is one of a series of thirteen black-and-white paintings that he termed Epiphanies. They are at once sensuous and biomorphic, rigorous and exacting. Stout's point of reference for the

curvilinear forms was the length and outline of his own arm; his torso was the pivot point, a fixed axis out of which he generated the anthropomorphic contour. He was very interested in the mystical aspects and sense of proportion in Greek art; he admired the human drama implied in its symbols. He also expressed admiration without reservation for Mondrian. Although Stout rejected Mondrian's dogmatic rectilinearity, he found the early purist to be able somehow to mystically address the human condition in the context of a severe and austere geometry.

All of the artists included in *Sitting on the Edge* seem to be situated somewhere in between an overt debt to Mondrian, on the one hand, and their role as either precursors or proponents of minimalism, on the other. And it is interesting that, although the artworks in the exhibition display similarities in their ultimate form, the painters can be polar opposites in terms of their philosophy and intent. McLaughlin shared a metaphysical or psychic reading with Albers, while Stout was fascinated by the implied humanity of certain geometric forms. Diller was certainly not seduced by such romantic notions, and Judd defined himself in opposition to them and was a resolute and devoted empiricist. The radically reductive tendencies of all of the *Sitting on the Edge* artists are clear, but something else ultimately unites them. As Ad Reinhardt stated, "One can find some of painting's meanings by looking not only at what painters do but at what they refuse to do."[2] These artists refused to depict an object, to refer to nature metaphorically, to deceive with spatial illusionism—in short,

to hide or encode meaning. By virtue of their refusal to take an autobiographical stance, they pursued a kind of anonymity and universality—and the resulting silencing of the natural world. The finished artworks are themselves objects—self-referential and complete—objects to inspire contemplation.

A tradition of painting—one that extends from the easel panting of earlier centuries to post–World War II large-scale action painting and tachism—affords limitless variations with regard to "touch," "feel," "stroke," "painterliness," and so on. But when these issues are strenuously avoided—when reproduction and depiction are totally eliminated—when the human hand is factored out entirely—the artist is left with the prospect of construction.

NOTES
1. Henry-Russell Hitchcock, *Painting toward Architecture* (New York: Duell, Sloan and Pearce, 1948).
2. Ad Reinhardt, "Abstract Art Refuses," in *Art as Art: The Selected Writings of Ad Reinhardt*, ed. Barbara Rose (New York: Viking, 1975), 50.

Plate 105
Myron Stout
Heirophant, 1955–79

CATALOGUE OF THE EXHIBITION

AALTO, ALVAR
FINNISH, 1898–1976

1

TEA TROLLEY

1935–36

Wood, rubber
22¼ x 35 x 19¾ in. (56.5 x 88.9 x 50.2 cm)
Manufacturer: Oy Huonekalu-ja
Rakennuslyötehdas AB, Turku, Finland
Plate 40

ALBERS, JOSEF
AMERICAN, BORN GERMANY, 1888–1976

2

HOMAGE TO THE SQUARE, GREEN TENSION

1951

Oil on Masonite
23⅝ x 23⅝ in. (60 x 60 cm)
Plate 101, figure 10

ALBINI, FRANCO
ITALIAN, 1905–1977

3

ARMCHAIR

1952

Pearwood, oak, fabric
27¼ x 23¼ x 19 in. (69.2 x 59.1 x 48.3 cm)
San Francisco Museum of Modern Art,
gift of Michael and Gabrielle Boyd, 96.589
Plate 71

ARSTRÖM, FOLKE
SWEDISH, BORN 1907

4

COCKTAIL SHAKER

1935

Silver- and nickel-plated brass, Bakelite
8¾ x 3½ x 2⅞ in. (22.2 x 8.9 x 7.3 cm)
Manufacturer: GuldsmedsAktieBolaget
GAB, Stockholm

154

BEHRENS, PETER
GERMAN, 1868–1940

5

SIDE CHAIR FOR THE HOUSE OF THE POET RICHARD DEHMEL

HAMBURG, 1903

Painted wood, tapestry
36⅝ x 17⅜ x 17⅜ in.
(93 x 44.1 x 44.1 cm)
Plate 1

6

DESK LAMP

c. 1920s

Bakelite
18¾ x 12⅞ x 6⅝ in.
(47.7 x 32.7 x 16.8 cm)
Manufacturer: Allgemeine Elektrizitäts-
Gesellschaft, Germany
Plate 13

BILL, MAX
SWISS, 1908–1994

7

THREE-LEGGED CHAIR

c. 1950

Birch
29½ x 17¼ x 19¼ in. (74.9 x 43.8 x 48.9 cm)
Manufacturer: Wohnbedarf AG, Zurich
Plate 78

8

CLOCK

1954

Painted metal, plastic
10 x 7 x 2 in. (25.4 x 17.8 x 5.1 cm)
Manufacturer: Zanotta s.p.a., Nova
Milanese, Italy

BORSANI, OSVALDO
ITALIAN, 1911–1985

9

LOUNGE CHAIR, MODEL P40

1954

Painted steel, fabric
33¾ x 27⅞ x 35½ in.
(85.7 x 69.5 x 90.2 cm)
Manufacturer: Tecno, Milan
Plate 79

10

THREE-LEGGED CHAIR

c. 1955

Painted steel, wood
26½ x 22½ x 22½ in.
(67.3 x 57.2 x 57.2 cm)
Manufacturer: Tecno, Milan
Plate 81

BOYD, MICHAEL
AMERICAN, BORN 1960

11

UNTITLED, FOUR PART PAINTING

1990

Acrylic on canvas mounted on plywood
Left to right: 28⅝ x 10⅛ x ¾ in. (72.7 x
25.7 x 1.9 cm); 22¾ x 10⅜ x ¾ in. (57.8 x
26.4 x 1.9 cm); 19 x 25⅛ x ¾ in. (48.3 x
63.8 x 1.9 cm); 28¾ x 6¼ x ¾ in.
(73 x 15.9 x 1.9 cm)
Figure 4

12

UNTITLED CONSTRUCTION

1991

Oil on wood
24 x 24 x 1⅝ in. (60.9 x 60.9 x 4.1 cm)
Figure 3

BOYD, MICHAEL
AMERICAN, BORN 1960
+
JOY, DAVEN
AMERICAN, BORN 1961

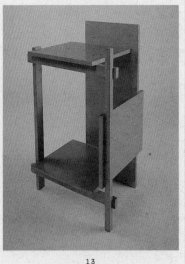

13

TELEPHONE TABLE

1991

Maple, aluminum paint
29¾ x 17⅞ x 14 in. (75.7 x 45.4 x 35.6 cm)
San Francisco Museum of Modern Art,
gift of the artists, 97.582
Figure 2

BOYD, MICHAEL
AMERICAN, BORN 1960
+
LAMERS, ERIC
AMERICAN, BORN 1960

14

CHAIR

1989

Douglas fir plywood, gesso
28¼ x 16⅛ x 19¼ in. (71.8 x 41 x 49 cm)
Figure 1

BREUER, MARCEL
AMERICAN, BORN HUNGARY, 1902–1981

15

SLATTED ARMCHAIR

1922–24

Painted wood, fabric
35 x 22½ x 21½ in. (88.9 x 57.2 x 54.6 cm)
Manufacturer: Furniture Workshop,
Staatliches Bauhaus, Weimar, Germany
Plate 10, figure 8

16

NESTING TABLES, MODEL B9

1925–26

Nickel-plated tubular steel, painted wood
Largest: 23⅝ x 23¾ x 15½ in.
(60 x 60.3 x 39.4 cm)
Manufacturer: Standard-Möbel
Lengyel & Co., Berlin
Plate 15

17

ADJUSTABLE CHAIR, MODEL B7A

1926–27

Chrome-plated tubular steel, painted
wood, Eisengarn fabric
32¼ x 22 x 22 in. (81.9 x 55.9 x 55.9 cm)
Manufacturer: Thonet
Plate 16

18

TABLE, MODEL B19

1928

Tubular steel, glass, rubber
27⅜ x 45½ x 32¼ in.
(69.5 x 115.6 x 81.9 cm)
Manufacturer: Thonet
Plate 23

19

LOUNGE CHAIR, MODEL B35

1928–29

Chrome-plated tubular steel, canvas,
painted wood
32 x 22 x 30 in. (81.3 x 55.9 x 76.2 cm)
Manufacturer: Thonet
Plate 26

20

SIDE CHAIR

1932

Aluminum, fabric
29¾ x 16½ x 21¼ in.
(75.6 x 41.9 x 54 cm)
Manufacturer: Wohnbedarf AG, Zurich
Plate 33

21
NESTING TABLES
1936
Painted plywood
Largest: 14¾ x 18¼ x 24 in.
(37.5 x 41.9 x 54 cm)
Manufacturer: Isokon Furniture Co.,
London
Plate 47

CASTIGLIONI, ACHILLE
ITALIAN, BORN 1918
+
CASTIGLIONI, PIER GIACOMO
ITALIAN, 1913–1968

22
MEZZADRO STOOL, MODEL 220
1957
Chrome-plated steel, painted steel,
beech
20½ x 15½ x 17 in. (52.1 x 39.4 x 43.2 cm)
Manufacturer: Zanotta s.p.a., Nova
Milanese, Italy
Plate 88, figure 9

CASTLE, WENDELL
AMERICAN, BORN 1932

23
MOLAR CHAIR
1969–70
Fiberglass-reinforced polyester
29 x 17 x 20½ in. (73.7 x 43.2 x 52.1 cm)
Manufacturer: Beylerian Ltd., New York
Plate 96

CHAREAU, PIERRE
FRENCH, 1883–1950

24
SIDE TABLE
c. 1927
Steel, wood
15⅞ x 23½ x 17¾ in.
(40.3 x 59.7 x 45.1 cm)
Plate 19

CHERMAYEFF, SERGE
AMERICAN, BORN RUSSIA, 1900–1996

25
RADIO, MODEL AC74
1933
Bakelite, metal
17¾ x 15 x 10 in. (45.1 x 38.1 x 25.4 cm)
Manufacturer: E. K. Cole & Co., Ltd.,
England
Plate 37

COLOMBO, JOE
ITALIAN, 1930–1971

26
UNIVERSALE CHAIR, MODEL 4860
1965
ABS plastic
28⅛ x 16⁹⁄₁₆ x 19⅛ in.
(71.4 x 42.1 x 48.5 cm)
Manufacturer: Kartell, Noviglio, Milan
San Francisco Museum of Modern Art,
gift of Michael & Gabrielle Boyd, 97.584

CORAY, HANS
SWISS, 1906–1991

27
LANDI STACKING CHAIR
1938
Anodized aluminum, rubber
30¼ x 20 x 24½ in. (76.8 x 50.8 x 62.3 cm)
Manufacturer: P. & W. Blattmann
Metallwarenfabrik, Wädenswil,
Switzerland
Plate 45

DILLER, BURGOYNE
AMERICAN, 1906–1965

28
FIRST THEME
1959–60
Oil on canvas
50 x 50 in. (127 x 127 cm)

29
FIRST THEME
1959–60
Oil on canvas
42½ x 42½ in. (108 x 108 cm)
Plate 102

30
FIRST THEME
1964
Oil on Masonite
23⅞ x 23⅞ in. (60.6 x 60.6 cm)

DREYFUSS, HENRY
AMERICAN, 1904–1972

31
**THERMOS PITCHER,
GLASS, AND TRAY**
1935
Aluminum, enameled steel, glass
Pitcher: 5⅞ x 6⅛ x 4¾ in.
(14.9 x 15.6 x 12 cm)
Glass: h: 2¾ in. (7 cm); diam: 2¾ in. (7 cm)
Tray: ½ x 9¼ x 6⅝ in. (1.2 x 23.7 x 16.9 cm)
Manufacturer: American Thermos Bottle
Co., Norwich, Connecticut

EAMES, CHARLES
AMERICAN, 1907–1978
+
EAMES, RAY
AMERICAN, 1913–1988

32
LEG SPLINT
1942
Plywood
42½ x 8 x 3½ in. (108 x 20.3 x 8.9 cm)
Manufacturer: Evans Products Co.,
Los Angeles
Figure 20

33
LCM CHAIR
1945–46
Painted steel, plywood, cowhide
26½ x 22 x 25 in. (67.3 x 55.9 x 63.5 cm)
Manufacturer: Herman Miller Furniture
Co., Zeeland, Michigan
Plate 55

34
STORAGE UNIT
1949–50
Painted steel, fiberglass, Masonite,
painted wood
58½ x 46¾ x 16¾ in.
(148.6 x 118.8 x 42.6 cm)
Manufacturer: Herman Miller Furniture
Co., Zeeland, Michigan
Plate 62, figure 5

35
RAR CHAIR
1950
Fiberglass-reinforced polyester,
metal, birch
26¾ x 24¾ x 27 in. (68 x 62.9 x 68.6 cm)
Manufacturer: Herman Miller Furniture
Co., Zeeland, Michigan
Plate 65

36
DKW-2 CHAIR
1951
Wood, steel, fabric
32½ x 18⅞ x 17 in. (82.6 x 48 x 43.2 cm)
Manufacturer: Herman Miller Furniture
Co., Zeeland, Michigan
Plate 67

37
**PROTOTYPE FOR THE
DOWEL-LEGGED SIDE TABLE**
c. 1950s
Wood, painted metal, Formica
11½ x 13⅞ x 13⅞ in.
(29.2 x 35.2 x 35.2 cm)
Plate 66

GOFF, BRUCE
AMERICAN, 1904–1982

38
STOOL FOR THE PRICE HOUSE
BARTLESVILLE, OKLAHOMA, 1957
Wood, vinyl
16 x 35 x 29 in. (40.6 x 88.9 x 73.7 cm)
Plate 76

GOLDMAN, PAUL
AMERICAN, BORN 1912

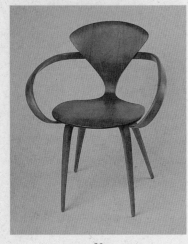

39
CHERNER CHAIR
1956–57

Wood
31¼ x 26½ x 23½ in.
(79.4 x 67.3 x 59.7 cm)
Manufacturer: Plycraft Ltd., Lawrence,
Massachusetts

GRAY, EILEEN
IRISH, 1878–1976

40
STUDY FOR THE BRENTANO RUG
c. 1925

Pochoir on paper
6 x 5⅝ in. (15.2 x 14.3 cm)

GUHL, WILLY
SWISS, BORN 1915

41
GARDEN CHAIR
1954

Fibrated concrete
21⁷⁄₁₆ x 21⁷⁄₁₆ x 30⅛ in.
(54.5 x 54.5 x 76.5 cm)
Manufacturer: Eternit AG, Niederurnen,
Switzerland
Plate 73

HARLIS, EDELHARDT
GERMAN

42
CHAIR, MODEL ST664
c. 1955

Painted steel, laminated plywood
32 x 22 x 25¼ in. (81.3 x 55.9 x 64.1 cm)
Manufacturer: Thonet
Plate 86

HERBST, RENÉ
FRENCH, 1891–1982

43
ARMCHAIR
1930

Nickel-plated tubular steel, zebra hide
25¾ x 19¾ x 17¾ in.
(65.4 x 50.2 x 45.1 cm)
Plate 31

44
CHAIR
1930

Nickel-plated tubular steel, zebra hide
28⅛ x 17¼ x 15¾ in. (71.4 x 43.8 x 40 cm)

HOFFMANN, JOSEF
AUSTRIAN, BORN MORAVIA,
1870–1956

45
CHAIR
1904

Painted wood, fabric
29¼ x 21¼ x 17½ in. (74.3 x 54 x 44.5 cm)
Manufacturer: J. & J. Kohn, Vienna
Plate 3

46
VASE
1904

Painted metal, glass
8½ x 4⅝ x 4⅝ in. (21.6 x 11.7 x 11.7 cm)
Manufacturer: Wiener Werkstätte, Vienna
Plate 5

47
BASKET
1905

Painted metal
H: 5¾ in. (14.6 cm); diam: 5⅞ in. (14.9 cm)
Manufacturer: Wiener Werkstätte, Vienna

48
TABLE
c. 1905

Painted wood
H: 28⅞ in. (73.3 cm);
diam: 26⅞ in. (68.3 cm)
Manufacturer: J. & J. Kohn, Vienna
Plate 6

49
ARMCHAIR
1928–29

Painted wood, leather
31¼ x 20 x 20½ in. (79.3 x 50.8 x 52.1 cm)
Manufacturer: Thonet
Plate 28

JACOBSEN, ARNE
DANISH, 1902–1971

50
SWAN CHAIR, MODEL 3320
1957–58

Leather, aluminum
32 x 29¼ x 23½ in. (81.3 x 74.3 x 59.7 cm)
Manufacturer: Fritz Hansen, Allerød,
Denmark
Plate 89

51
HIGH-BACK OXFORD CHAIR
1960

Aluminum, leather
49¾ x 18½ x 20½ in.
(126.4 x 47 x 52.1 cm)
Manufacturer: Fritz Hansen, Allerød,
Denmark
Plate 93

52
CHAIR PROTOTYPE
c. 1960

Aluminum, wool, plastic
31⅜ x 17¾ x 18½ in. (79.8 x 45.1 x 47 cm)
Plate 94

JOHNSON, DAN
AMERICAN

53
DINING CHAIR FROM
THE GAZELLE LINE
1958

Wood, brass, split cane
32¼ x 18 x 19 in. (81.9 x 45.7 x 48.3 cm)
Manufacturer: Dan Johnson Studio,
Rome, for Arch Industries, Inc.
Plate 91

JUDD, DONALD
AMERICAN, 1928–1994

54
GALVANIZED STEEL CHAIR
1984

Galvanized steel
29½ x 19¾ x 19¾ in.
(74.9 x 50.2 x 50.2 cm)
Manufacturer: Lehni AG, Switzerland
Plate 100

55
PROTOTYPE FOR
THE LIBRARY CHAIR
1985

Pine
29½ x 15¾ x 15¾ in. (74.9 x 40 x 40 cm)
Plate 98

56
UNTITLED (SWISS BOX)
1987

Painted aluminum
11⅞ x 71 x 11⅞ in.
(30.2 x 180.3 x 30.2 cm)
Plate 103

57
CHAIRS
1988

Maple
30⅛ x 15 x 15 in. (76.5 x 38.1 x 38.1 cm)
each
Manufacturer: Cooper/Kato, New York
(ed. 5/30)
Plate 99

JUHL, FINN
DANISH, 1912–1989

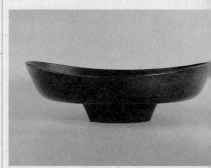

58
BOWL
1954

Teak
4¼ x 14⅜ x 14 in. (10.8 x 36.5 x 35.6 cm)
Manufacturer: Magne Monsen for Kay
Bojesen, Copenhagen

KAGAN, VLADIMIR
AMERICAN, BORN GERMANY, 1927

59
STOOL
1955

Aluminum, vinyl
13¾ x 22⅜ x 19⅝ in.
(34.9 x 56.8 x 49.8 cm)
Manufacturer: Vladimir Kagan Designs
Inc., New York
Plate 82

LASSEN, MORGENS
DANISH, 1901–1987

60
STOOL
1942

Teak
18⅞ x 19⅞ x 14³⁄₁₆ in.
(47.9 x 50.5 x 36 cm)
Manufacturer: K. Thomsen, Denmark
Plate 49

LASZLO, PAUL
AMERICAN, BORN HUNGARY, 1900

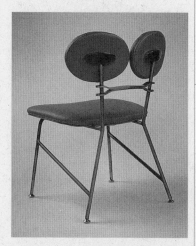

61
CHAIR FOR THE MCCULLOUGH CHAINSAW FACTORY
c. 1950s

Steel, leather, brass
28½ x 19¾ x 19¾ in.
(72.4 x 50.2 x 50.2 cm)

LE CORBUSIER
FRENCH, BORN SWITZERLAND, 1887–1965

62
TABLE FOR THE CITÉ DE REFUGE DE L'ARMÉE DU SALUT
PARIS, 1929

Painted steel, wood, linoleum
29⅜ x 43½ x 25⅞ in.
(74.6 x 110.5 x 65.7 cm)
Plate 29

63
LIGHT FIXTURE FOR THE CITÉ UNIVERSITAIRE DE PARIS, MAISON DU CAMBODGE
PARIS, 1950

Painted metal
4¾ x 9⅞ x 5¾ in. (12.1 x 25.1 x 14.6 cm)
Plate 30

LE CORBUSIER
FRENCH, BORN SWITZERLAND, 1887–1965
+
PERRIAND, CHARLOTTE
FRENCH, BORN 1903
+
JEANNERET, PIERRE
FRENCH, 1896–1967

64
CHAISE LONGUE, MODEL LC-4
1928

Chrome-plated tubular steel, painted steel, rope, canvas
26½ x 62½ x 19½ in.
(67.3 x 158.8 x 49.5 cm)
Manufacturer: Embru-Werke AG, Rüti, Zurich

Plate 24

LESCAZE, WILLIAM
AMERICAN, BORN SWITZERLAND, 1896–1969

65
SALT AND PEPPER SHAKERS
c. 1935

Metal, plastic
1¾ x 1⅛ x 2 in. (4.5 x 2.9 x 5.1 cm) each

LOOS, ADOLF
AUSTRIAN, 1870–1933

66
FOOTREST
c. 1905

Wood, leather
13⅝ x 18⅜ x 8¾ in.
(34.6 x 46.7 x 22.2 cm)
Manufacturer: J. & J. Kohn, Vienna
Plate 7

MALLET-STEVENS
ROBERT
FRENCH, 1886–1945

67
STACKING CHAIR
1928

Painted tubular and sheet steel
33 x 16 x 17 in. (83.8 x 40.6 x 43.2 cm)
Plate 25

68
DESK
c. 1930

Nickel-plated steel, painted oak
29⅜ x 70¾ x 31⅜ in.
(74.6 x 179.7 x 79.7 cm)
Plate 34

McARTHUR, ALBERT
CHASE
AMERICAN, 1881–1951
+
KOPTA, EMRY
AMERICAN, BORN AUSTRIA, 1884–1953

69
LIGHT BOX COVER FOR THE ARIZONA BILTMORE HOTEL,
PHOENIX, c. 1930

Milk glass
6¼ x 8⅜ x ⅞ in. (15.9 x 21.3 x 2.2 cm)
San Francisco Museum of Modern Art, gift of Michael & Gabrielle Boyd, 97.610

McARTHUR, WARREN
AMERICAN, 1885–1961

70
TABLE FOR THE ARIZONA BILTMORE HOTEL
PHOENIX, c. 1930

Painted steel, wrought iron
28¼ x 31 x 35½ in. (71.8 x 78.7 x 90.2 cm)
Plate 20

71
ARMCHAIR
1933

Tubular anodized aluminum, vinyl
33 x 24 x 24 in. (84 x 61 x 61 cm)
Manufacturer: Warren McArthur Corp., Los Angeles and New York
Plate 32

72
LOUNGE CHAIR
c. 1935

Tubular anodized aluminum, vinyl
31½ x 23¼ x 30 in. (80 x 59.1 x 76.2 cm)
Manufacturer: Warren McArthur Corp., Los Angeles and New York
Plate 41

73
OTTOMAN
c. 1935

Tubular anodized aluminum, vinyl
17 x 23¾ x 25¼ in.
(43.2 x 60.3 x 64.1 cm)
Manufacturer: Warren McArthur Corp., Los Angeles and New York

McLAUGHLIN, JOHN
AMERICAN, 1898–1976

74
UNTITLED
1957

Oil on Masonite
48 x 32 in. (121.9 x 81.3 cm)
Plate 104

MIES VAN DER ROHE
LUDWIG
AMERICAN, BORN GERMANY, 1886–1969

75
CHAIR, MODEL MR10
1927

Chrome-plated tubular steel, cane
31⁵⁄₁₆ x 18⅝ x 27¹⁵⁄₁₆ in.
(79.5 x 46.5 x 71 cm)
Manufacturer: Berliner Metallgewerbe Josef Müller, Berlin
Plate 18

76
ARMCHAIR, MODEL MR20
1927

Chrome-plated tubular steel, canvas
32 x 21 x 32 in. (81.3 x 53.3 x 81.3 cm)
Manufacturer: Thonet
Plate 17

77
TABLE, MODEL MR515
1927

Chrome-plated tubular steel, glass
H: 24⅛ in. (61.3 cm);
diam: 19¾ in. (50.2 cm)
Manufacturer: Thonet

MOLLINO, CARLO
ITALIAN, 1905–1973

78
WALL UNIT FOR THE ISTITUTO COOPERAZIONE SANITARIA
TURIN, ITALY, 1945–47

Oak, glass, brass
94 x 93¼ x 23¾ in.
(238.8 x 236.9 x 60.3 cm)
San Francisco Museum of Modern Art, gift of Michael & Gabrielle Boyd, 97.594.A–C

79
SIDE CHAIR FOR THE CASA DEL SOLE
CERVINIA, ITALY, 1947

Oak, brass
36½ x 14 x 18 in. (92.7 x 35.6 x 45.7 cm)
Manufacturer: Apelli & Varesio, Turin, Italy
Plate 51, figure 7

80
TABLE FOR THE PAVIA RESTAURANT
CERVINIA, ITALY, 1954

Wood
30½ x 31¼ x 31¼ in.
(77.5 x 79.3 x 79.4 cm)
Plate 75

MOUILLE, SERGE
FRENCH, 1922–1988

81
FLOOR LAMP
1953

Painted metal
64⅝ x 18¼ x 28½ in.
(164.2 x 46.5 x 72.4 cm)
Plate 74

MÜLLER-MUNK, PETER
AMERICAN, BORN GERMANY, 1904–1967

82
NORMANDIE PITCHER
c. 1935

Chrome-plated brass
12 x 9½ x 3 in. (30.5 x 24.1 x 7.6 cm)
Manufacturer: Revere Copper & Brass Co., Rome, New York

GEORGE NELSON ASSOCIATES
AMERICAN

83
BALL CLOCK
1949

Painted wood, brass, steel
Diam: 12⅞ in. (32.7 cm);
depth: 2¾ in. (7 cm)
Manufacturer: Howard Miller Clock Co., Zeeland, Michigan
Plate 61

84
VANITY STOOL
1952

Tubular aluminum, vinyl
20 x 20 x 18½ in. (50.8 x 50.8 x 47 cm)
Manufacturer: Herman Miller Furniture Co., Zeeland, Michigan
Plate 69

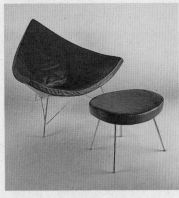

85
COCONUT CHAIR AND OTTOMAN
1955–56

Chrome-plated and painted steel, leather
Chair: 32½ x 40½ x 28½ in.
(82.5 x 102.9 x 72.4 cm)
Ottoman: 16 x 23 x 18¾ in.
(40.6 x 58.4 x 47.6 cm)
Manufacturer: Herman Miller Furniture Co., Zeeland, Michigan

86
MARSHMALLOW SOFA
1956

Painted tubular and sheet steel, wool
30⁵⁄₁₆ x 51¾ x 31½ in. (77 x 131.5 x 80 cm)
Manufacturer: Herman Miller Furniture Co., Zeeland, Michigan
Plate 84

87
DAF CHAIR FROM THE SWAGGED-LEG SERIES,
1956–58

Painted steel, fiberglass
28¼ x 28⅜ x 21½ in.
(71.8 x 72.1 x 54.6 cm)
Manufacturer: Herman Miller Furniture Co., Zeeland, Michigan
Frontispiece, plate 85

NEUTRA, RICHARD
AMERICAN, BORN AUSTRIA, 1892–1970

88
TABLE FOR THE TREMAINE HOUSE
MONTECITO, CALIFORNIA, 1948

Wood
26½ x 49¾ x 35½ in.
(67.3 x 126.4 x 90.2 cm)
Plate 58

89
SIDE CHAIR
c. 1950

Metal, wood, vinyl
31½ x 17¼ x 20½ in. (80 x 43.8 x 52.1 cm)
Plate 68

NOGUCHI, ISAMU
AMERICAN, 1904–1988

90
RADIO NURSE
1937

Bakelite, metal, rubber
8⅜ x 6½ x 6¼ in. (21.3 x 16.5 x 15.9 cm)
Manufacturer: Zenith Radio Corp., Chicago
Plate 50

91
FIN TABLE
1949–50

Formica, painted wood
26 x 51³⁄₁₆ x 36 in. (66 x 130 x 91.4 cm)
Manufacturer: Herman Miller Furniture Co., Zeeland, Michigan
Plate 63

92
ROCKING STOOL
1954

Chrome-plated steel, wood
H: 10½ in. (26.7 cm); diam: 14 in. (35.6 cm)
Manufacturer: Knoll International, New York
Plate 77

NOLL, ALEXANDER
FRENCH, 1890–1970

93
PITCHER AND TRAY
c. 1950

Sycamore
Pitcher: 9⅞ x 7 x 5¼ in.
(25.1 x 17.8 x 13.3 cm)
Tray: 13⅞ x 19¼ x 2¼ in.
(35.2 x 48.9 x 5.7 cm)
Plate 64

OUD, J. J. P.
DUTCH, 1890–1963

94
GISO TABLE LAMP, MODEL 405
1928

Nickel-plated copper
10½ x 9 x 8½ in. (26.7 x 22.9 x 21.6 cm)
Manufacturer: W. H. Gispen, Rotterdam and Amsterdam
Plate 27

PANTON, VERNER
DANISH, BORN 1926

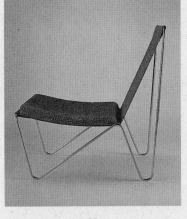

95
BACHELOR CHAIR
1956

Stainless steel, fabric
29 x 21 x 29 in. (73.7 x 53.3 x 73.7 cm)
Manufacturer: Fritz Hansen, Allerød, Denmark
San Francisco Museum of Modern Art, gift of Michael & Gabrielle Boyd, 97.597

96
CONE CHAIR
1958

Aluminum, fabric
33¼ x 23½ x 26 in. (84.5 x 59.7 x 66 cm)
Manufacturer: Fritz Hansen, Allerød, Denmark
Plate 90

97
STACKING CHAIR
1960

Plastic
33 x 19½ x 21 in. (83.8 x 49.5 x 53.3 cm)
Manufacturer: Herman Miller Furniture Co., Zeeland, Michigan
Plate 95

PERRIAND, CHARLOTTE
FRENCH, BORN 1903

+

PROUVÉ, JEAN
FRENCH, 1901–1984

+

Polychrome by
DELAUNAY, SONIA
FRENCH, 1885–1979

98
WALL UNIT FOR THE MAISON DU MÉXIQUE
PARIS, 1952

Painted fiberboard, pine, painted steel
63⅜ x 71¾ x 12⅛ in.
(161 x 182.3 x 30.8 cm)
Manufacturer: Les Ateliers Jean Prouvé,
France

Plate 70

PONTI, GIO
ITALIAN, 1891–1979

99
CHAIR PROTOTYPE FOR THE MONTECATINI BUILDING
MILAN, c. 1935

Aluminum
34⅛ x 17⅛ x 16½ in.
(86.7 x 43.5 x 41.9 cm)
Plate 42

100
CHAIRS FOR THE MONTECATINI BUILDING
MILAN, 1936

Aluminum, vinyl
a. 35¼ x 23 x 20 in.
 (89.5 x 58.4 x 50.8 cm)
b. 31½ x 16 x 16 in. (80 x 40.6 x 40.6 cm)
c. 34 x 17 x 21 in. (86.4 x 43.2 x 53.3 cm)
d. 30¼ x 25½ x 20½ in.
 (76.8 x 64.8 x 52 cm)
e. 31½ x 16 x 16 in. (80 x 40.6 x 40.6 cm)
f. 32½ x 17¼ x 19 in.
 (82.6 x 43.8 x 48.3 cm)
Manufacturer: Ditta Parma Antonio e
Figli, Saronno, Italy
Plates 43–44

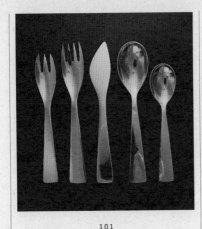

101
FLATWARE
1951

Stainless steel
Salad fork: 6⅝ x 1 x ½ in.
(16.8 x 2.5 x 1.3 cm)
Fork: 7⅛ x 1⅛ x ⅝ in.
(18 x 2.9 x 1.6 cm)
Knife: 7⅜ x 1¼ x ⅛ in. (18.7 x 3.2 x .3 cm)
Soup spoon: 7 x 1⅝ x ⅞ in.
(17.8 x 4.1 x 2.2 cm)
Teaspoon: 6 x 1⅜ x ⅝ in.
(15.2 x 3.5 x 1.6 cm)
Manufacturer: Argenteria Krupp, Milan,
Italy, for Fraser's, Italy

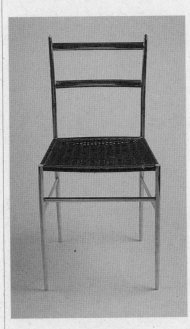

102
SIDE CHAIR
c. 1955

Steel, cane
32 x 16 x 17¼ in. (81.3 x 40.6 x 43.8 cm)
Manufacturer: Figli di Amedeo Cassina,
Meda, Milan
San Francisco Museum of Modern Art,
gift of Michael & Gabrielle Boyd, 96.608

103
SMOKER'S SET
c. 1950s

Ceramic
Tray: 1¼ x 8 x 8 in. (3.2 x 20.3 x 20.3 cm)
Cigarette bowl: h: 3⅛ in. (7.9 cm);
diam: 3¼ in. (8.3 cm)
Match bowl: h: 1¾ in. (4.4 cm);
diam: 1⅞ in. (4.8 cm)
Ashtray: h: 2⅛ in. (5.4 cm);
diam: 4⅛ in. (10.5 cm)
Manufacturer: Richard Ginori, Italy

PROUVÉ, JEAN
FRENCH, 1901–1984

104
CHAIR
1948

Painted steel, plywood
31⅝ x 16⅛ x 18½ in. (80.3 x 41 x 47 cm)
Manufacturer: Les Ateliers Jean Prouvé,
France

Plate 54

105
ARMCHAIR
1948

Painted steel, wood, vinyl
30½ x 24⅜ x 22 in. (77.5 x 61.9 x 55.9 cm)
Manufacturer: Les Ateliers Jean Prouvé,
France

Plate 59

106
ANTONY CHAIR
1950

Painted steel, plywood, vinyl
34 x 20 x 27 in. (86.4 x 50.8 x 68.6 cm)
Manufacturer: Les Ateliers Jean Prouvé,
France

Plate 60

107
DAYBED
c. 1950s

Painted steel, oak
10½ x 75 x 40½ in.
(26.7 x 190.5 x 102.9 cm)
Manufacturer: Les Ateliers Jean Prouvé,
France
San Francisco Museum of Modern Art,
gift of Michael & Gabrielle Boyd, 97.599

108
STOOL
c. 1950s

Painted steel, oak, aluminum
H: 28½ in. (72.4 cm);
diam: 17¼ in. (43.8 cm)
Manufacturer: Les Ateliers Jean Prouvé,
France

Plate 53

PUIFORCAT, JEAN
FRENCH, 1897–1945

109
HORS D'OEUVRES UTENSILS
c. 1925

Silver-plated metal
Fork: 4⅜ x 1⅛ x ⅜ in. (11.1 x 2.9 x 1.1 cm)
Knife: 5¼ x ¾ x ⅛ in. (13.3 x 1.9 x .3 cm)
Spoon: 5 x 1½ x ½ in. (12.7 x 3.8 x 1.3 cm)
Manufacturer: Cartier, Paris

RIETVELD, GERRIT
DUTCH, 1888–1964

110
RED/BLUE CHAIR
1918

Painted beech, plywood
34½ x 26 x 32½ in. (87.6 x 66 x 82.6 cm)
Manufacturer: Gerard A. van de
Groenekan, Utrecht, Holland
Plate 8

111
SIDE TABLE
c. 1920

Painted wood
23¾ x 19½ x 20¼ in.
(60.3 x 49.5 x 51.4 cm)
Manufacturer: Gerard A. van de
Groenekan, Utrecht, Holland
Plate 9

112
MILITAR CHAIR
1923

Painted oak, plywood
35⅜ x 15¾ x 20 in. (89.9 x 40 x 50.9 cm)
Manufacturer: Gerard A. van de
Groenekan, Utrecht, Holland
Plate 11

113
COAT RACK
c. 1925

Wrought iron
7⅞ x 27¾ x 9¼ in. (20 x 70.5 x 23.5 cm)

114
BEUGELSTOEL
1927

Nickel-plated tubular steel, painted
plywood
28¾ x 15⅝ x 22 in. (73 x 39.7 x 55.9 cm)
Manufacturer: Metz & Co., Amsterdam
Plate 22

115
BEUGELSTOEL
1927

Nickel-plated tubular steel, painted
plywood
23½ x 15⅝ x 24½ in.
(59.7 x 39.1 x 62.2 cm)
Manufacturer: Metz & Co., Amsterdam

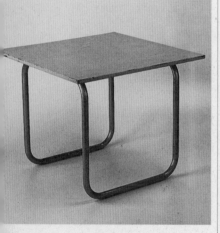

116
OCCASIONAL TABLE
c. 1930

Chrome-plated tubular steel, painted
wood
24½ x 29½ x 29½ in.
(62.2 x 74.9 x 74.9 cm)
Manufacturer: Metz & Co., Amsterdam

117
CRATE CHAIR
1934

Wood
23 x 22¼ x 30⅜ in. (58.4 x 56.5 x 77.2 cm)
Manufacturer: Metz & Co., Amsterdam
Plate 38

118
ZIG-ZAG CHAIR
1934

Painted elm
29½ x 14½ x 17 in.
(74.9 x 36.8 x 43.2 cm)
Manufacturer: Gerard A. van de
Groenekan, Utrecht, Holland
San Francisco Museum of Modern Art,
gift of Michael & Gabrielle Boyd, 96.609
Figure 14

119
WRITING DESK
c. 1940s

Painted wood
27⅝ x 36¾ x 23⅝ in. (70.2 x 93.4 x 60 cm)
Manufacturer: Gerard A. van de
Groenekan, Utrecht, Holland
Plate 48

120
STELTMAN CHAIR
1964

Limed oak
27½ x 19⅝ x 17¾ in.
(69.9 x 49.9 x 45.1 cm)
Manufacturer: Gerard A. van de
Groenekan, Utrecht, Holland
Cover, plate 97

ROHDE, GILBERT
AMERICAN, 1894–1944

121
TABLE LAMP
c. 1933

Chrome-plated steel, painted brass
6⅞ x 13¼ x 2⅜ in. (17.5 x 33.7 x 6 cm)
Manufacturer: Mutual-Sunset Lamp
Manufacturing Co., Inc., Brooklyn

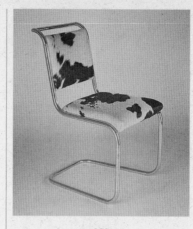

122
CHAIR
c. 1940

Chrome-plated tubular steel, cowhide
32 x 16 x 16 in. (81.3 x 40.6 x 40.6 cm)
Manufacturer: Herman Miller Furniture
Co., Zeeland, Michigan
San Francisco Museum of Modern Art,
gift of Michael & Gabrielle Boyd, 97.601

SAARINEN, EERO
AMERICAN, BORN FINLAND,
1910–1961

123
CHAIR
1946

Steel, plastic, vinyl
31¾ x 21½ x 18 in. (80.7 x 54.6 x 45.7 cm)
Manufacturer: Knoll International,
New York
Plate 56

124
TULIP STOOL
1955–56

Plastic-coated steel, vinyl
16 x 14½ x 14½ in. (40.6 x 36.8 x 36.8 cm)
Manufacturer: Knoll International,
New York
Plate 83

SCARPA, CARLO
ITALIAN, 1906–1978

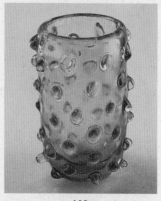

125
VASE
1936

Glass
H: 12 in. (30.5 cm); diam: 8 in. (20.3 cm)
Manufacturer: Venini, Italy

SCHINDLER, RUDOLPH
AMERICAN, 1887–1953

126
CHAIR FOR THE LECHNER HOUSE
LOS ANGELES, 1948

Plywood, fabric
31 x 15 x 23¾ in.
(78.7 x 38.1 x 60.3 cm)
Plate 57

STAM, MART
DUTCH, 1899–1986

127
ARMCHAIR
c. 1925

Tubular steel, painted wood
31¼ x 21 x 18 in.
(79.4 x 53.3 x 45.7 cm)
Manufacturer: Thonet
Plate 14

128
CHAIR
c. 1925

Tubular steel, painted wood
31½ x 15½ x 18 in.
(80 x 39.4 x 45.7 cm)
Manufacturer: Thonet

STONE, EDWARD DURELL
AMERICAN, 1902–1978

129
CHAIR
1945–46

Wood, cane
35¼ x 18⅛ x 27 in. (89.5 x 46 x 68.6 cm)
Manufacturer: Fulbright Industries,
Fayetteville, Arkansas
Plate 52

STOUT, MYRON
AMERICAN, 1908–1987

130
HEIROPHANT
1955–79

Oil on canvas
37¾ x 30 in. (95.9 x 76.2 cm)
Plate 105

TEAGUE, WALTER DORWIN
AMERICAN, 1883–1960

131
DESK LAMP, MODEL 114
1939

Bakelite, aluminum
12¾ x 11¾ x 9¾ in.
(32.4 x 29.9 x 24.8 cm)
Manufacturer: Polaroid Corporation,
Cambridge, Massachusetts
San Francisco Museum of Modern Art,
gift of Michael & Gabrielle Boyd, 97.606
Plate 46

TERRAGNI, GIUSEPPE
ITALIAN, 1904–1943

132
**ARMCHAIR FOR THE
CASA DEL FASCIO**
COMO, ITALY, 1932–36

Chrome-plated tubular steel, leather
31 x 21 x 26 in. (78.7 x 53.3 x 66 cm)
Manufacturer: Zanotta s.p.a., Nova
Milanese, Italy
San Francisco Museum of Modern Art,
gift of Michael & Gabrielle Boyd, 97.607

VAN DOESBURG, THEO
DUTCH, 1883–1931

133
DE STIJL, NOS. 9 AND 12
1924–25

Ink on paper
8 x 10³⁄₁₆ in. (20.3 x 25.9 cm) each

WAGENFELD, WILHELM
GERMAN, 1900–1990

134
SINTRAX COFFEE MAKER
1931

Glass, painted wood, aluminum, plastic
11⅜ x 9 x 5½ in. (28.9 x 22.9 x 14 cm)
Manufacturer: Schott & Gen. Jena'er
Glassworks, Jena, Germany
Plate 35

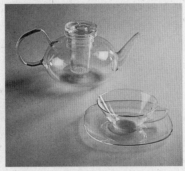

135
TEA SERVICE
1932

Glass
Teapot: 4½ x 10½ x 6⅛ in.
(11.4 x 26.7 x 15.6 cm)
Cup: h: 1½ in. (3.8 cm);
diam: 4¼ in. (10.8 cm)
Saucer: h: ½ in. (1.3 cm);
diam: 6½ in. (16.5 cm)
Manufacturer: Schott & Gen. Jena'er
Glassworks, Jena, Germany

136
KUBUS STORAGE CONTAINERS
1938

Glass
Overall: 8⅜ x 10⅞ x 7¼ in.
(21.3 x 27.6 x 18.4 cm)
Manufacturer: Vereinigte Lausitzer
Glaswerke AG, Weißwasser, Germany
Plate 36

WAGNER, OTTO
AUSTRIAN, 1841–1918

137
ARMCHAIR
c. 1902

Stained beechwood, plywood
31¾ x 22⅜ x 22 in. (80.7 x 56.8 x 55.9 cm)
Manufacturer: J. & J. Kohn, Vienna
Plate 2

WEBER, KEM
AMERICAN, BORN GERMANY,
1889–1963

138
AIRLINE ARMCHAIR
1934–35

Wood, plywood, leather
31½ x 25 x 34 in. (80 x 63.5 x 86.3 cm)
Manufacturer: Airline Chair Co.,
Los Angeles

Plate 39

WEGNER, HANS J.
DANISH, BORN 1914

139
OX CHAIR AND OTTOMAN
1960

Steel, leather
Chair: 34¼ x 32½ x 34 in.
(87 x 82.6 x 86.4 cm)
Ottoman: 14 x 29½ x 18 in.
(35.6 x 74.9 x 45.7 cm)
Manufacturer: Johannes Hansen,
Copenhagen

Plate 92

WILDENHAIN, MARGUERITE
AMERICAN, BORN FRANCE, 1896–1985

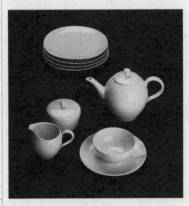

140
COFFEE SET
1931

Porcelain
Plate: h: ¾ in. (1.9 cm);
diam: 7⅝ in. (19.4 cm)
Coffeepot: 5¼ x 7⅞ x 4½ in.
(13.3 x 20 x 11.4 cm)
Sugar bowl: h: 3 in. (7.6 cm);
diam: 3¼ in. (8.3 cm)
Creamer: 3⅛ x 4¼ x 3 in.
(7.9 x 10.8 x 7.6 cm)
Cup: h: 1⅝ in. (4.1 cm);
diam: 3⅞ in. (9.8 cm)
Saucer: h: ⅝ in. (1.6 cm);
diam: 6⅛ in. (15.6 cm)

WRIGHT, FRANK LLOYD
AMERICAN, 1867–1959

141
**SIDE CHAIR FOR THE
LARKIN COMPANY
ADMINISTRATION BUILDING**
BUFFALO, NEW YORK, 1902–6

Painted steel, leather
35⅛ x 14 x 18¾ in. (89.2 x 35.6 x 47.6 cm)
Plate 4

142
SKYSCRAPER VASE
c. 1905

Ceramic
22½ x 6⅛ x 3½ in. (57.2 x 15.6 x 8.9 cm)
San Francisco Museum of Modern Art,
gift of Michael & Gabrielle Boyd, 96.615

143
**PEACOCK CHAIR FOR THE
IMPERIAL HOTEL, TOKYO**
1921–22

Oak, vinyl, brass
38¼ x 15½ x 19 in. (97.2 x 39.4 x 48.3 cm)
Plate 12

144
USONIAN HASSOCK
c. 1940

Plywood, vinyl
17 x 16 x 16 in. (43.2 x 40.6 x 40.6 cm)
Plate 21

YANAGI, SORI
JAPANESE, BORN 1915

145
BUTTERFLY STOOL
1954–56

Plywood, brass
16⁵⁄₁₆ x 18¹¹⁄₁₆ x 13⅜ in.
(41.4 x 47.5 x 34 cm)
Manufacturer: Tendo Mokko Co., Ltd.,
Tokyo

Plate 80

ZANUSO, MARCO
ITALIAN, BORN 1916

146
LADY ARMCHAIR
1951

Steel, fabric
30 x 30½ x 31¼ in. (76.2 x 77.5 x 79.4 cm)
Manufacturer: Arflex International, Meda,
Milan

Plate 72

ZANUSO, MARCO
ITALIAN, BORN 1916

+ SAPPER, RICHARD
GERMAN, BORN 1932

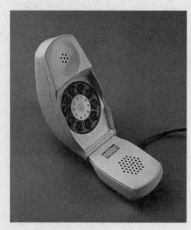

147
GRILLO TELEPHONE
1965

ABS plastic
Telephone: 2¾ x 6¾ x 3 in.
(7 x 17.2 x 7.6 cm)
Connector: 3½ x 2½ x 1⅛ in.
(8.9 x 6.4 x 4.8 cm)
Manufacturer: Italtel/Società Italiana
Telecomunicazione, Milan

ZEISEL, EVA
AMERICAN, BORN HUNGARY, 1906

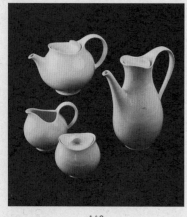

148
TOMORROW'S CLASSIC
c. 1950

Porcelain
Teapot: 5¾ x 8¾ x 5¼ in.
(14.6 x 22.2 x 13.3 cm)
Coffeepot: 9⅛ x 7¾ x 4¼ in.
(23.2 x 19.7 x 10.8 cm)
Creamer: 4¼ x 5 x 3¾ in.
(10.8 x 12.7 x 9.5 cm)
Sugar bowl: 3⅝ x 4 x 3½ in.
(9.2 x 10.2 x 8.9 cm)
Manufacturer: Hall China Co., Liverpool,
Ohio

149
MIXING BOWL
c. 1950s

Plastic
4½ x 7¾ x 6 in. (11.4 x 19.7 x 15.2 cm)
Manufacturer: Stanley Flex Plastic, U.S.A.

DESIGNER UNKNOWN

150
PICNIC CHAIR
FRANCE, c. 1900

Painted metal
16¼ x 15¼ x 6¼ in.
(41.3 x 38.7 x 15.9 cm)

151
ARCHITECT'S LAMP
FRANCE, c. 1915

Wood, painted metal
17¼ x 14½ x 7¼ in. (43.8 x 36.8 x 18.4 cm)

152
DOBRO GUITAR
c. 1930

Nickel-plated steel
14 x 38 x 3¼ in. (35.6 x 96.5 x 8.3 cm)
Manufacturer: National Steel Co., U.S.A.

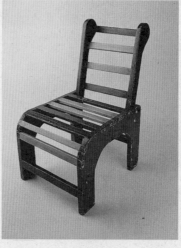

153
CHILD'S CHAIR
THE NETHERLANDS, c. 1930s

Painted wood
21½ x 12 x 17¼ in. (54.6 x 30.5 x 43.8 cm)

154
COCKTAIL SHAKER
GERMANY, c. 1930s

Nickel-plated metal
3 x 8¾ x 3 in. (7.6 x 22.2 x 7.6 cm)

155
PITCHER AND CUPS
c. 1930s

Silver-plated brass
Pitcher: 7 x 8⅝ x 7 in.
(17.8 x 21.9 x 17.8 cm)
Cup: 4½ x 2½ x 2½ in.
(11.4 x 6.4 x 6.4 cm)
Manufacturer: Middletown Silverware,
Middletown, Connecticut

156
TEAPOT
c. 1930s

Pewter, plastic
5¾ x 9½ x 7¼ in. (14.6 x 24.1 x 18.4 cm)